BUFFALO

Anita Yasuda

All Roads Lead to Buffalo

Schiffer Publishing Ltd

4880 Lower Valley Road, Atlgen, PA 19310

Other Schiffer Books by Anita Yasuda
Snapshots of San Diego: Sun, Surf, & Sand, 978-0-7643-2883-1, $14.95

Other Schiffer Books on Related Subjects
Greetings from Niagara Falls, 978-0-7643-2801-5, $19.95
Schiffer Publishing, Ltd. offers a wide variety of books detailing the histories of cities throughout the region through pictures and postcards. Please visit our web site for more great titles.

Copyright © 2008 by Anita Yasuda
Library of Congress Control Number: 2007942247

Designed by John P. Cheek
Cover design by Bruce Waters
Type set in New Baskerville BT/Zurich BT

ISBN: 978-0-7643-2888-6
Printed in China

Schiffer Books are available at special discounts for bulk purchases for sales promotions or premiums. Special editions, including personalized covers, corporate imprints, and excerpts can be created in large quantities for special needs. For more information contact the publisher:

Published by Schiffer Publishing Ltd.
4880 Lower Valley Road
Atglen, PA 19310
Phone: (610) 593-1777; Fax: (610) 593-2002
E-mail: Info@schifferbooks.com

For the largest selection of fine reference books on this and related subjects, please visit our web site at **www.schifferbooks.com**
We are always looking for people to write books on new and related subjects. If you have an idea for a book please contact us at the above address.

This book may be purchased from the publisher.
Include $3.95 for shipping.
Please try your bookstore first.
You may write for a free catalog.

In Europe, Schiffer books are distributed by
Bushwood Books
6 Marksbury Ave.
Kew Gardens
Surrey TW9 4JF England
Phone: 44 (0) 20 8392-8585; Fax: 44 (0) 20 8392-9876
E-mail: info@bushwoodbooks.co.uk
Website: www.bushwoodbooks.co.uk
Free postage in the U.K., Europe; air mail at cost.

Dedication

For Kaylee Emi.

"And so gliding along the Tonewanda Creek, and by the great rushing Niagara river, which seemed hurrying clown to the foaming rapids and the tremendous fall below, we glided into Buffalo. A gay and hospitable city, I thought, as we swept slowly into a suburb, where young ladies, dressed in pink and blue, with plenty of rouge and ringlets, welcomed us from their open windows and balconies. I soon found, however, that this portion of Buffalo was about as fair a representation of the city…" — *Dr. Thomas L. Nichols, traveler, "Forty years of American Life."*

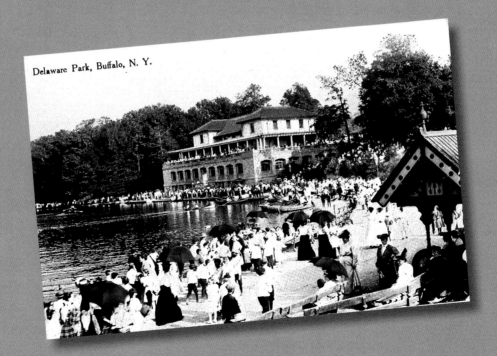

Children's Day in Delawarc Park. Circa 1910s, divided back, $4-6.

Preface

This book is both a collection of memories of yesteryear and memories currently in the making. Postcards by their very nature are snapshots of a time briefly spent in a place...Not one you would call your "hometown," but one you quickly moved through during your travels. The postcard represents something that caught your eye — a person, a place or an event that encapsulated your entire travel to that city.

This book is both a nostalgic look at Buffalo's past through turn-of-the-century postcards and a look at Buffalo's present through snapshots of summer festivals. The postcards have been paired up with first hand accounts from the eighteenth and nineteenth centuries, of travelers' first impressions of Buffalo. There were two criteria for the quotes: one, that they were primary sources and two, that they were visitors to the city.

The older images have also been paired up with new photos that show Buffalo as it is now — vibrant and classic. These photos represent the modern postcard that tourists take away with them from this city.

The book is organized along the lines of an old tour. Many tourists to the Buffalo region before the advent of the railroad came by water. The first chapter is therefore dedicated to sights around the Buffalo harbor. The second chapter is 'In the town' and takes you, the reader, on a walking tour of Buffalo's historic buildings in its downtown district.

Chapter Three is dedicated to the present-day Buffalo. Tourists in the late 1800s might have simply checked into a hotel, but in 2007 the streets of Buffalo are bustling with activity. The city of Buffalo plays host to events throughout the year. The Allentown Arts Festival and Taste of Buffalo are two large summer events that draw people to the Buffalo region, sometimes for the very first time.

After the excitement of the festival, Chapter Four takes a quieter turn along Delaware Avenue. Our traveler in the past would have had a letter of introduction to permit his entry into one the homes along the avenue; today, it is simply a case of taking a historic tour or visiting the Theodore Roosevelt national historic site. Afterwards, a visit to Delaware Park is essential. The park is part of the Frederick Law Olmsted-designed

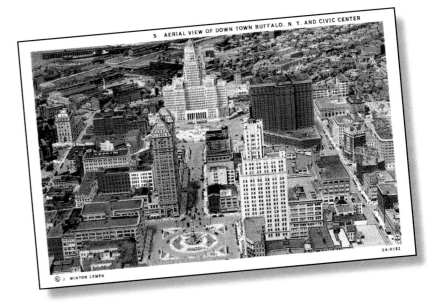

Aerial View of Down Town Buffalo and Civic Center. Circa 1930s, divided back, $5-7.

national historic park system in Buffalo. Sit by Hoyt Lake or, in the summer months, catch a performance of 'Shakespeare in the Park.'

Chapter Five is the last stop on the tour and ends with a glimpse of the Niagara Falls. Many turn-of-the-century tourists to Buffalo only stayed a night before going onto the Falls. With the advent of the railroad, more tourists flooded to the area. This section uses quotes from tourists who traveled by rail from Buffalo to check out this natural wonder of the world.

The author hopes that this book will be a reminder of days well spent in Buffalo. The sub-title of the book comes from a map produced for the Pan-American Exposition — *All Roads Lead to Buffalo* — held from May 1 through November 2, 1901. Perhaps one of the roads you travel will lead to Buffalo again and again.

Acknowledgments

Thank you to the people of Buffalo. Your city was a pleasure to photograph and visit. Like many visitors to Buffalo, this author was impressed by its timeless grandeur. This book was an independent project tracing a traveler's footsteps from the turn-of-the-century and a traveler from the twenty-first century through antique postcards, diaries, and books to current festivals and sights.

In addition, thank you to the Landmark Society of the Niagara Frontier, the Preservation Coalition of Erie County, the Buffalo Niagara Convention & Visitors Bureau, and the dedication of countless volunteers who work tirelessly to preserve and promote Buffalo's historic places.

In addition:
The Library of Congress
The National Register of Historic Places
The Buffalo and Erie County Public Library

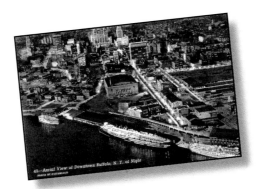

**Aerial View of downtown Buffalo at Night. Circa
1940s, divided back, $3-5.**

"Buffalo stands close by the mouth of a small creek, which affords a harbour for the trading vessels. A small light-house has been recently built, to guide the benighted mariner to its sheltering haven; and a large steam boat has just begun to navigate the lake, which is appropriately named, after a celebrated Indian chief, Walk-in-the-Water. The position of the town is very favourable for commerce. The great western canal will terminate within two miles of it, and it will then become the great thoroughfare between the lower country, and Lake Erie, the State of Ohio, and the rest of the western territory." — *John M. Duncan, traveler, "Travels through Part of the United States and Canada, 1818-1819," 1823*

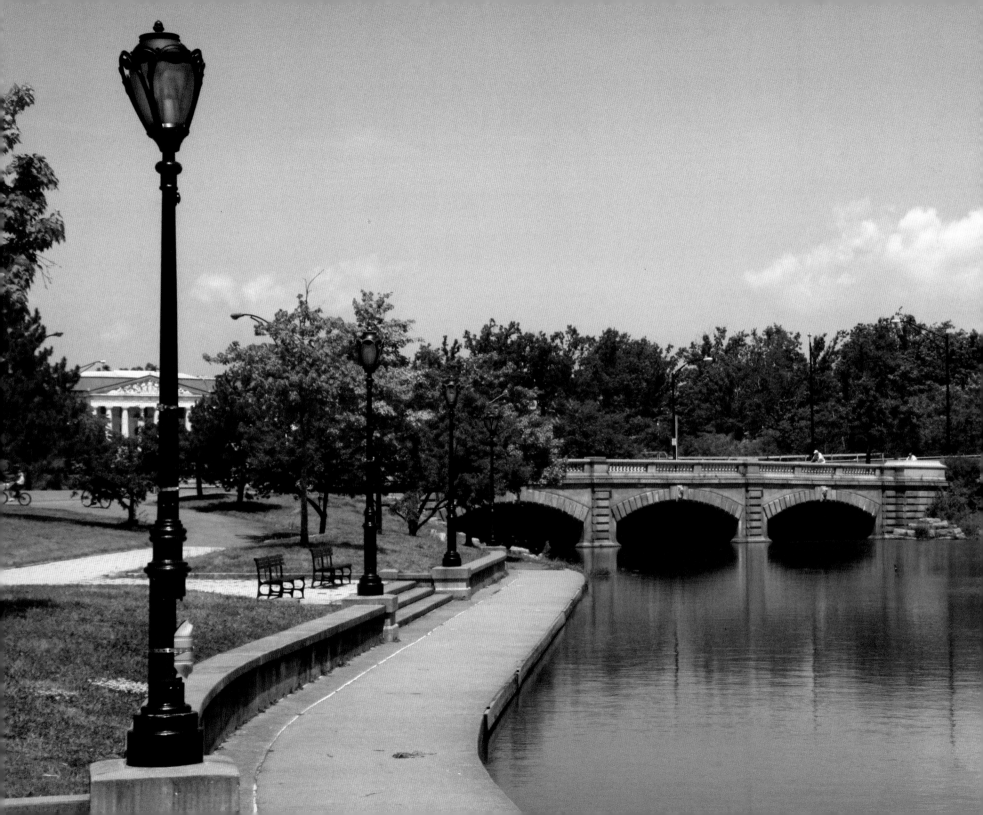

Contents

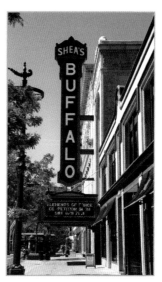
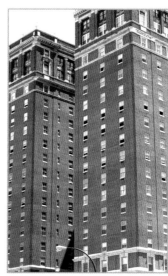
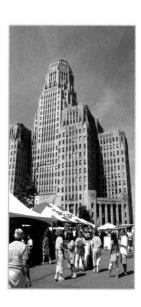

Introduction

The United States is full of spectacular locations, but there is one lakeside city that really has it all. Lakeside pathways to bike or walk along, stunning architecture, proximity to amazing camping and hiking areas, and hospitality are all part of what makes Buffalo and its surrounding area a city for all seasons. On the shores of Lake Erie, Buffalo was home to two American Presidents, more than one world-renowned architect, and home to sports stars and musicians. It is a popular destination for tourists north and south of the United States border with a major international airport making it an easily-accessible city. Buffalo is the perfect place to visit.

The opening of the Erie Canal in 1925 brought luxurious canal packets designed for express travel to Buffalo. People who could afford to could see this western city and the Niagara Falls beyond. Waterways were the lifelines of the settlements, bringing new residents, tourists, and of course, goods such as coal, flour or salt. The first railway into the area was the Buffalo & Erie Railroad Company, which was formed in early 1834. In 1836 the Buffalo Niagara Falls Railway began operating with two trains daily, and horses drew the train cars.[1] By the 1840s there were two daily steam-powered trains between Niagara and Buffalo and, with the opening of the Buffalo & Attica Railroad, the city was part of the chain of railroad stops that spanned the state. Luxury hotels in the region flourished even when guests had to arrive by coach and boat.

Today's visitor has his choice of transportation. The natural beauty, the stunning architecture, world-class art, sporting and music events, and the hospitality of the inhabitants attract an increasing number of tourists to the city. Buffalo can surprise you: one minute the modern tourist is traveling along the freeway looking at urban development, the next moment they're in a stunning city with many unique buildings. No matter what season, there is no reason not to discover the beauty of Buffalo. In the summer months, on festival days, Buffalo swells and becomes a bustling city with stores, restaurants, sidewalks, and docks teaming with tourists and locals.

It is also a place to take a summer boat cruise, watch the dragon boats down by the river, or jump aboard the bus tour and see historic Buffalo. On many summer weekends it's home to the festivals including the Taste of Buffalo and the Allentown Art Festival, which attracts tens of thousands of people annually.

When you browse your way through the many stalls that line the downtown streets, you will discover distinctive artisans and experience the unique flavor of the local Buffalo cuisine or visit the Frederick Law Olmstead park system listed on the National Register of Historic Places and the Albright-Knox Art Gallery, or go to a concert or a museum. In the summer you can bike or blade and, in the winter, there are hockey games and skating at Rotary Rink. After a full day of fun, you will be ready to relax and bask in the glow of a glorious Buffalo sunset while sitting at one of its numerous restaurants.

If you are looking for an outstanding day trip or a really great place to live, you will find it all in the Buffalo area.

Welcome to Buffalo. There are many opinions as to the origin of the Buffalo name. The Native Americans might have named the city after a place known as "Buffalo Creek." Some people believe that Buffalo is actually from the French "beau fleuve," which, loosely translated, means "beautiful river," referring to the Niagara River.

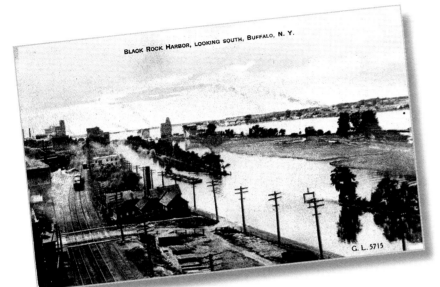

Black Rock Harbor, Looking South, Buffalo, New York. Black Rock is now a neighborhood in Buffalo, but it was once an independent community. Black Rock was annexed in 1832. Circa 1910s, divided back, $3-5.

Along the Water

"When I arrived in Buffalo, in the autumn of 1837, there was a population of from fifteen to twenty thousand inhabitants. There were broad streets, handsome squares, fine buildings, a nice theatre, spacious hotels, and a harbour full of steamboats. Each boat had its band of music playing on deck to attract the passengers as they came in on the mail-coaches or canal-boats." — *Thomas Low Nichols, traveler, Forty Years of American Life, 1864*

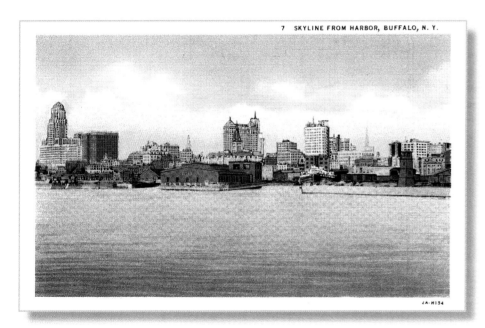

Skyline from Harbor, Buffalo, New York. Buffalo was transformed from small village to important shipping center after the Erie Canal opened in 1825. As shipping increased so did the railroads. New industries also brought with them immigrants to the city. Circa 1940s, $3-5.

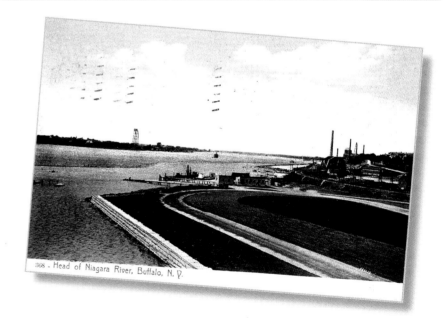

Head of Niagara River, Buffalo, New York. When Buffalo became the second largest city in New York State after New York City, it received the name, "The Queen City." This name was used during its semi-centennial celebration in 1882. With the Pan American Exposition of 1901 and the incredible electric displays, Buffalo received the name, "The City of Light." In more recent years the slogan, "City of Good Neighbors," has been used to reflect the friendly nature of the people of the city. Cancelled 1910, divided back, $3-5.
The back of the postcard reads: "To Miss Anna Spieth, Hello Dear, Having a fine time. Rode in a launch up this river and steered the boat myself — what do you think of that? Love from Elise." Dated August 2, 1910.

"Buffalo in summer was a lively as well as a cool and lovely place. We had a clever little company at the theatre, with all the stars that came from Europe and made the grand American tour. We had delightful quadrille parties, with ice-cream and champagne in a pretty public garden...And then we had steamboat excursions. Every new steamboat that came out, larger, faster, and more magnificent than its predecessors, gave a grand excursion. Sometimes we went fifty miles down the Niagara, making the circuit of Grand Island, and boldly steaming across the river, on the very edge of the rapids, where one minute's stoppage of the engine would have sent boat and passengers over the great cataract." — *Thomas Low Nichols, "Forty Years of American Life," 1864*

Entrance to Harbor, Buffalo, N. Y.

Entrance to Harbor, Buffalo, New York. The canal slowly became less important to Buffalo with the increasing use of the railroad. After the St. Lawrence Seaway opened in 1958, ships bypassed Buffalo, using the Great lakes to reach the Atlantic Ocean. Circa 1900s, undivided back, $3-5.

Bridges:

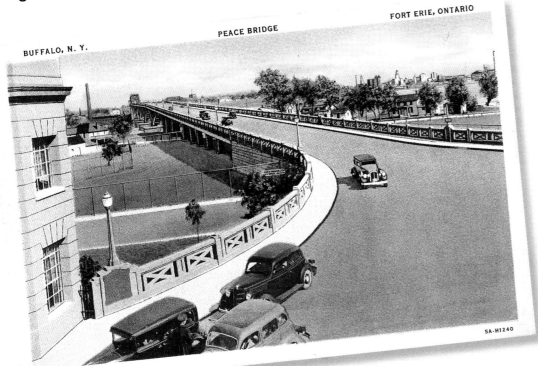

BUFFALO, N. Y. PEACE BRIDGE FORT ERIE, ONTARIO

5A-H1240

Peace Bridge. The name of the bridge commemorates the hundred years of peace between America and Canada. The bridge connects Buffalo, New York to the town of Fort Erie, Ontario. The bridge opened in June 1927 to the public. Circa 1930s, divided back, $4-6.

The back of the postcard reads: *"For safe, rapid convenient crossing of the Niagara River, use the Peace Bridge. The scenic-route to Niagara Falls and the shortest route to Detroit and the West. U.S. Terminal at foot of Vermont Street, Buffalo, New York."*

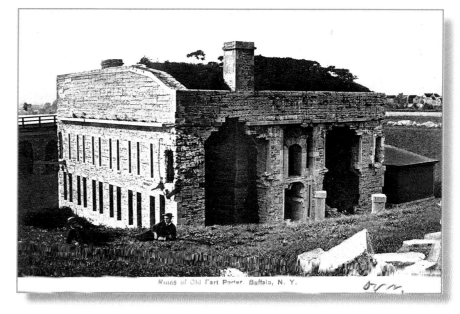

Ruins of Old Fort Porter. The fort was demolished in 1925 when construction began on the Peace Bridge. Cancelled 1909, divided back, $4-6.

Peace Bridge.
Circa 1940s, divided
back, $3-5.

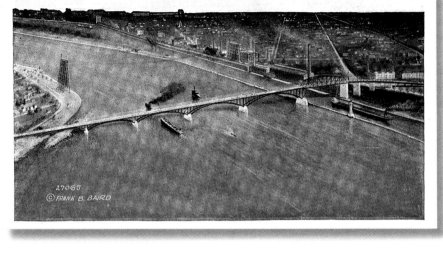

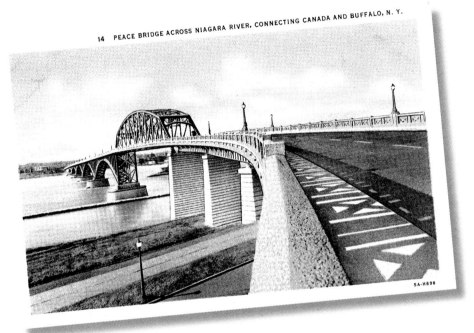

14 PEACE BRIDGE ACROSS NIAGARA RIVER, CONNECTING CANADA AND BUFFALO, N. Y.

Peace Bridge across Niagara River, con-
necting Canada to Buffalo, New York.
Circa 1940s, divided back, $3-5.

International Bridge over Niagara River. The
International Railway Bridge was built in 1873.
Cancelled 1913, divided back, $3-5.
The back of the postcard reads: *"Buffalo, June 28,*
1913, Hello Ella, How are you? Haven't heard a
word from you since you left. Awful. Lonesome here.
Even the Parrott has gone visiting. Rufus."

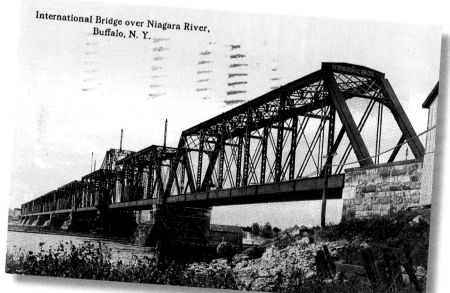

International Bridge over Niagara River,
Buffalo, N. Y.

Present:

"Buffalo is handsomely situated at the east end of Lake Erie, where it commands a beautiful view of the lake, of Upper Canada, and Fort Erie, and a great distance to the southward, which, is terminated by an elevated lofty country. The site of the town extends to a the lake shore, but it is principally built on an eminence of about thirty feet, a little distance; and to the south along the creek are handsome rich bottom lots, which are at present a little marshy, but will, when drained, be most valuable appendages to this very beautiful place. Buffalo was laid out for a town about five years ago, and is regularly disposed in streets and lots. The lots are from 60 to 100 feet deep, and sell from 25 to 50 dollars; and there are out-lots of five to ten acres, worth at present from ten to twenty-five dollars per acre. The population was by last census 365, it is now computed at 500, and is rapidly increasing. The buildings are mostly of wood, painted white, but there is a number of good brick houses, and some few of stone. There are four taverns, eight stores, two schools; and a weekly newspaper has been recently established. The town is as yet too new for the introduction of any manufacturers, except those of the domestic kind." — *John Melish, "Travels Through the United States of America," 1806-1811*

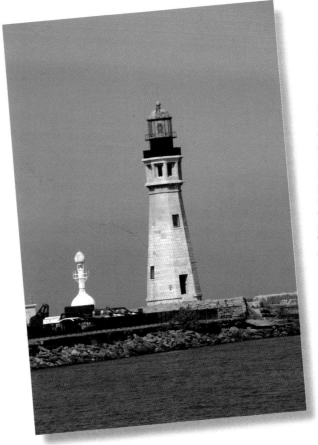

The Buffalo lighthouse was built in 1833. It is located at 1 Fuhrman Boulevard. It is a Buffalo landmark and its image is part of the seal of Buffalo. "The number of passengers who have left Buffalo for the West in steamboats alone, during the season, taking the average to the close will be from sixty-five to seventy thousand. The amount of tolls on the canal for the year 1629 was twenty-five thousand eight hundred and seventy-three dollars; for 1833, it was seventy thousand dollars." *Source: People Magazine Jan, 11, 1834 as reprinted by Library of Congress.*

A dragon boat crew practicing early in the morning. Along the river you will see joggers, cyclists, dog walkers and, of course, the Miss Buffalo cruise boat, which takes visitors on not-to-be missed sightseeing tours.

A close-up of the Hope Chest Dragon boat team.

"The Harbor at Buffalo which connects Lake Erie with Lake Ontario and the St. Lawrence; and the Erie Canal, with its terminus at Buffalo, connects the lakes with the great ocean commerce, which reaches us by way of New York and through the Hudson River. The latter waterways has so cheapened the carrying of freight to the interior of our country that Buffalo has become a great port. It is wonderful how a new waterway will often change the commerce of a country. The digging of the Erie Canal largely aided in making New York the greatest city in the United States. Before the canal was built, wheat was a very expensive article in the eastern states. In some places wheat bread was a luxury, and not to be used as a common food. Rye flour and corn meal took the place of wheat flour. It is through cheap water transportation that we are able to get flour at such low prices. How would you like to carry a bushel of wheat hundreds of miles for two cents? It now costs only about two cents to carry a bushel of wheat from Buffalo to New York by way of the Erie Canal." — *Frank G. Carpenter, "Carpenter's Geographical Reader: North America," 1898*

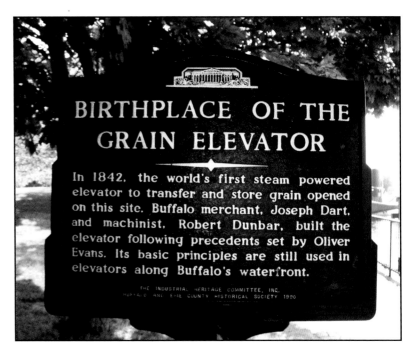

Historic Grain Elevator plaque.

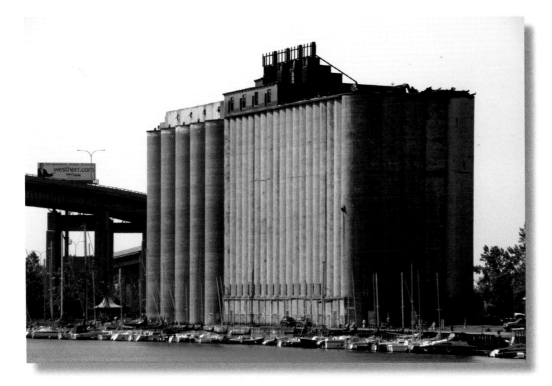

One of the historic elevators along the river.

"An hour's ride from Lancaster, on the morning of the nineteenth, brought to view the motley array of chimneys and towers that overtop the 'Queen City of the Lakes.' While making my way towards them, and receiving first impressions, my attention was attracted by a brigade drill on the parade ground, which I halted to witness. This was the first instance during my journey in which I had encountered any considerable body of military men…The marching and maneuvers evinced close attention to tactics and excellent discipline, and the equipment of officers and men reflected much credit upon the Empire State, which has every reason to be proud of these her citizen-soldiers." — *Willard W. Glazier, "Ocean to Ocean on Horseback," 1896*

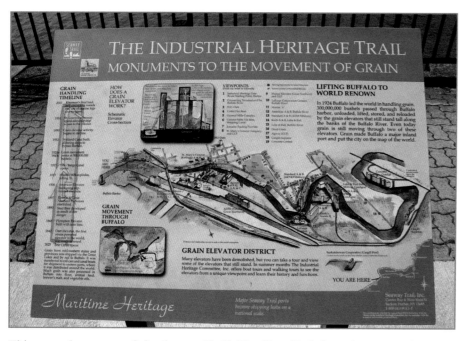

This map shows part of the Seaway Trail. The New York State Seaway Trail is 454 miles long.

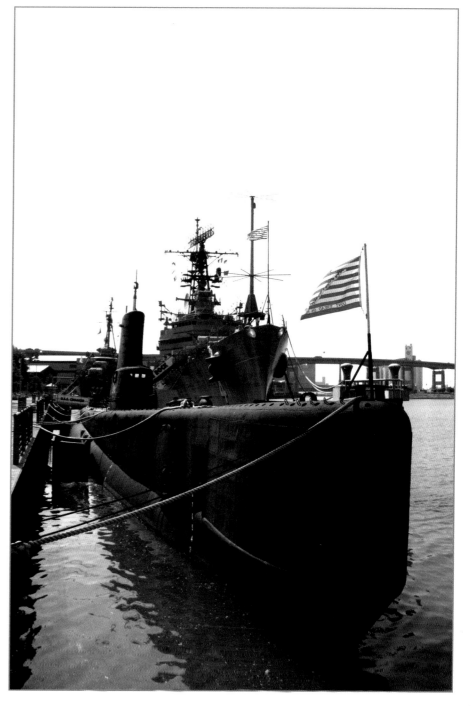

The USS Croaker at the Naval and Military Park.

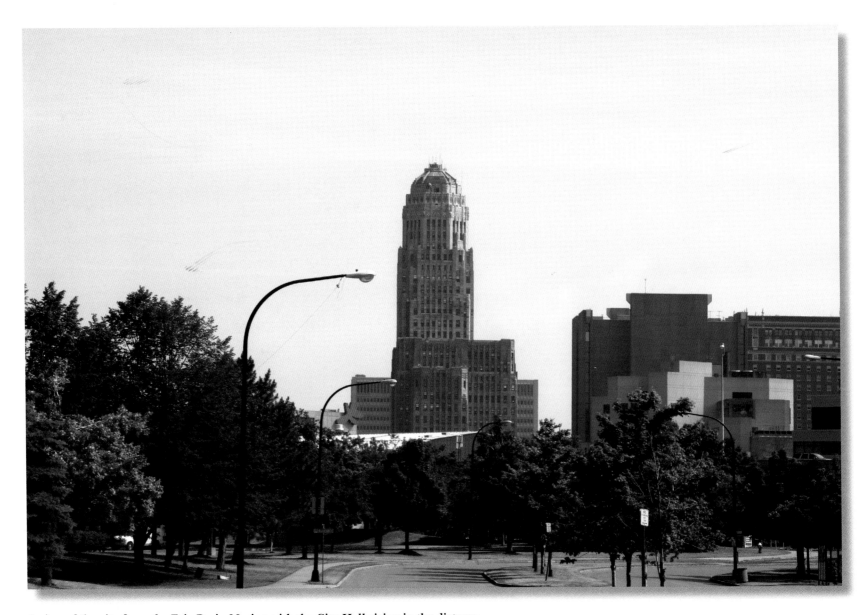

A view of the city from the Erie Basin Marina with the City Hall rising in the distance.

"I went to the little frontier city of Buffalo, in Western New York, at the outlet of Lake Erie into the Niagara river, about twenty miles south of the great cataract, in 1837. Railways had not at that time stretched across the Empire State. There were two modes of reaching Buffalo—the mail-coaches and the canal-packets. I chose the latter mode as the cheaper and pleasanter. The canal-packet is out of date, and would be considered very slow in these days; but it was not a bad way of getting through the world to one who had his whole life before him, who was fond of beautiful scenery, and was in no hurry. Our sharp, narrow, gaily-painted boat was drawn by three fine horses, each ridden by a smart boy, and we glided along at the regular pace of five miles an hour." — *Thomas Low Nichols, traveler, "Forty Years of American Life," 1864*

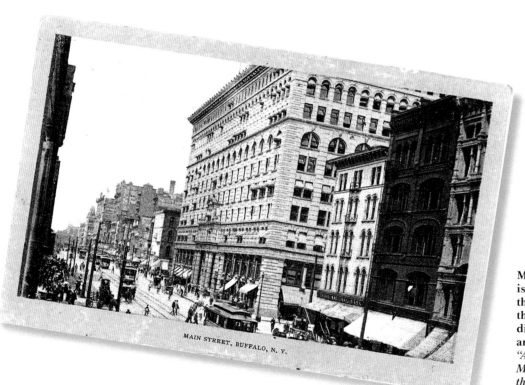

MAIN STREET, BUFFALO, N. Y.

Main Street. "Like most other new towns, Buffalo is composed in great part by one street following the course of the road towards the eastward, though the town itself lies very nearly in a north and south direction. A few others cross the main street, but are but little improved." — *William Darby, traveler, "A Tour from the City of New York to Detroit, in the Michigan Territory, made between the 2nd of May and the 22nd of September, 1818."* Circa 1900s, undivided back, $4-6.

Streets & Squares

"Buffalo is the third city in New York State, with a population estimated at 390,000, and is at the east end of Lake Erie, which is 290 miles long by 65 miles wide. It has some fine (residential) streets, imposing public buildings, and pleasant parks. The park system, almost a belt round the city, is very beautiful, there being almost 1,000 acres of park land cultivated at an annual cost of £500,000. The principal business thoroughfares are wide, and also beautiful, and the (residential) streets are wide and shaded, being heavily fringed with luxuriant foliage, and the dwellings well back. The city has received the name of the 'Bicyclist's Paradise,' because of its miles of asphalt streets, more numerous than in any other city in the world." — *Arthur Giles, "Across Western Waves and Home in a Royal Capital," 1898*

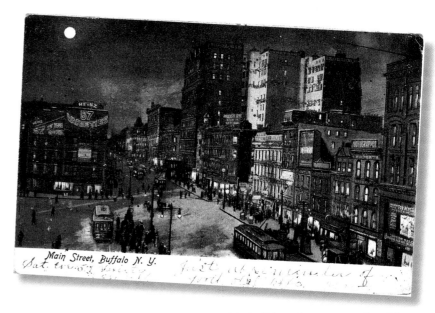

Main Street. Main Street is bustling with holiday shoppers and waiting streetcars. Cancelled 1906, undivided back, $3-5.
The back of the card reads: "September 18, 1906: To Leo Campbell, West Virginia: Just a reminder of grand old Buffalo."

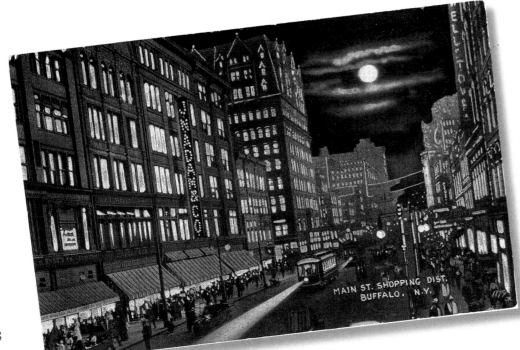

Main Street. Shopping District showing the crowds during the evening hours outside of the J.N. Adam and Co. department store; it was in business for nearly fifty years. Circa 1910s, divided back, $3-5.

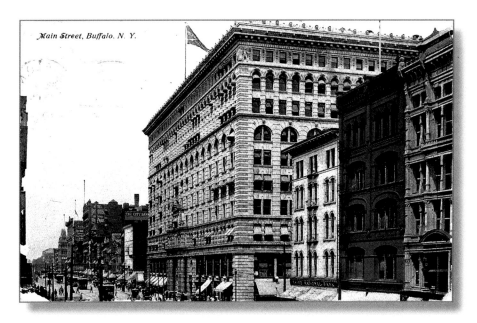

Main Street. Cancelled 1911, divided back, $3-5.
The back of the card reads: *"Mr. Reid Indiana, Buffalo, July 12, 1911: Dear Papa, Arrived at 6 this a.m., not very tired. Have had breakfast and looking for our rooms. Will start to the Falls. Love to all, Nettie."*

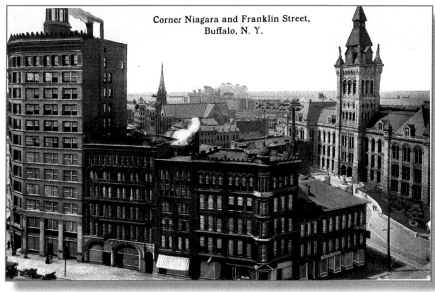

Corner of Niagara and Franklin streets. Circa 1930s, divided back, $3-5.

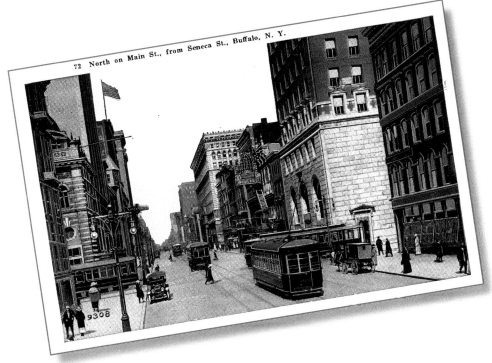

North on Main Street, from Seneca Street. Tramcars, a few automobiles and even a horse and buggy perfectly capture this turn-of-the-century moment. A vaudeville sign on the right side of the picture hints at the lively nightlife this street had during evening hours. Circa 1920s, divided back, $3-5.

19

Lafayette Square:

"The city is well laid out, the streets being ample length and breadth. And arranged with great symmetry. Main Street, which exceeds two miles in length, and is about 120 feet in breadth, is of finer proportions than the Broadway at New York, and has on each side of it massive piles of buildings, in shops, stores, dwellings, and hotels, which may vie with those of any other city in the Union, either for elegance of design, solidity of construction, internal comfort, or external appearance. Several squares are agreeably interspersed in different quarters of the town, enclosed by railings and planted with trees, to an area of beautiful lawn; while the views of the expanded surface of the lake and the more restricted area of the strait, which are seen from almost every part of the town, add great interest and beauty to the scene." — *James S. Buckingham, "America: Historical, Statistic, and Descriptive," 1841*

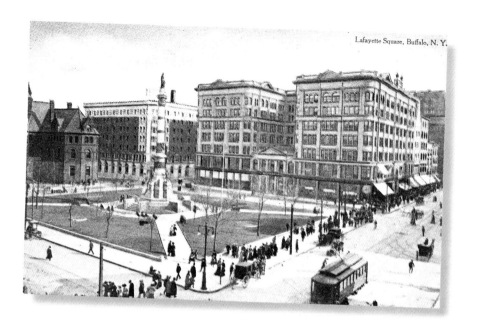

Lafayette Square, Buffalo, N.Y.

Main Street and Lafayette Square. Main, Clinton, Washington and Lafayette streets border the square. Joseph Ellicott devised the first street plan for the city of Buffalo in 1804. Circa 1910s, divided back, $4-6.

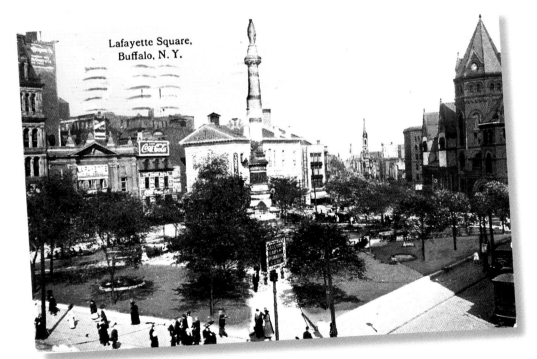

Lafayette Square, Buffalo, N.Y.

Lafayette Square. Cancelled 1913, divided back, $3-5.
Back of postcard reads: *"July 21, 1913, To Ray Bon, Durant, New York City. Am here in Buffalo now/having a grand time. Suppose you enjoy your trip too. Mite again have been busy and late. Velma."*

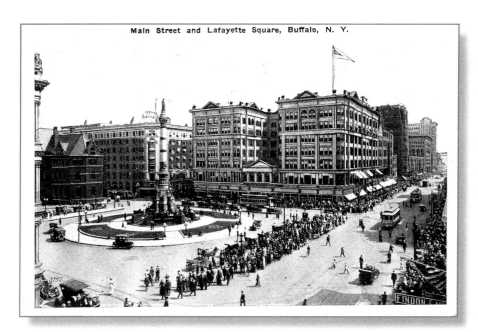

Main Street and Lafayette Square, Buffalo, N. Y.

Lafayette Square. The original name for the square was Court House Park. Joseph Ellicott laid out the square. Circa 1910s, divided back, $3-5.

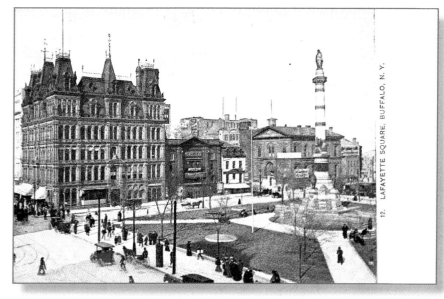

Main Street and Lafayette Square. Hansom cabs wait in Lafayette Square. Cancelled 1918, divided back, $4-6.

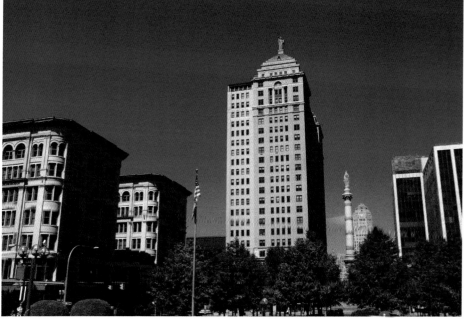

Standing just behind Lafayette Square, looking towards the Liberty Building.

Niagara Square:

"It is regularly built, partly on low ground intersected in the southern part by Buffalo creek. The site rises gently from the water's edge, and at the distance of two miles becomes an extended plain fifty feet above the level of the harbor. Main-street, two miles long, 120 feet wide, is the finest in the city, having lofty buildings on each side. There are three public squares, all of which are planted with shade and ornamental trees." — *John Warner Barber, traveler, "Our Whole Country," 1861*

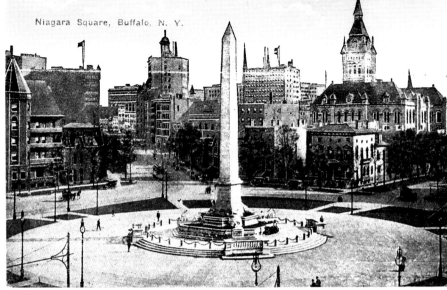

Niagara Square. Circa 1900s, divided back, $3-5.

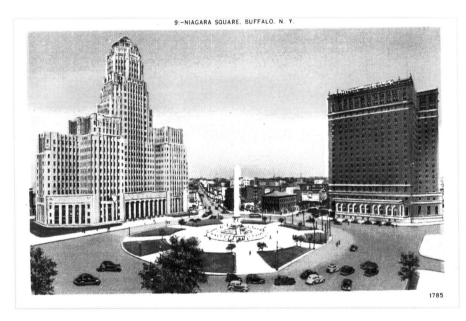

Niagara Square. Looking from Niagara Street, a number of Buffalo landmarks like City Hall, the McKinley monument and Hotel Statler are visible. Niagara Square is the official 'location' of Buffalo: 42 degrees, 53 minutes north, and longitude 78 degrees, 53 minutes west. Circa 1930s, divided back, $4-6.

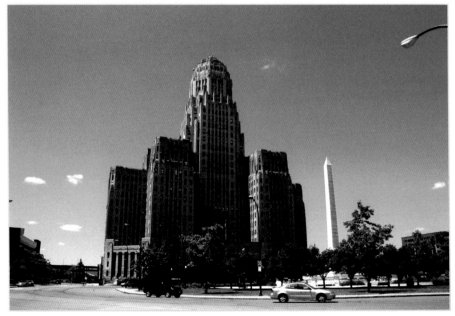

Today: watching the cars loop around the McKinley Monument with the beautiful art deco City Hall rising behind it.

Monuments & Memorials

McKinley Monument:

President McKinley was shot while at the exposition on September 6, 1901 and later died on September 14, 1901. The following is the address by the late President McKinley at the Pan-American Exposition on September 5, 1901:

"The construction of a pacific cable cannot be longer postponed. In the furtherance of these objects of national interest and concern, you are performing an important part. The good work will go on — it cannot be stopped. These buildings will disappear. This creation of art and beauty and industry will perish from sight. But who can tell the new thoughts that have awakened, the ambition fired, and the high achievement that will be wrought this exposition. Gentlemen, let us ever remember that our interest is in concord, not conflict. And that our real eminence rests in the victories of peace, not those of war."

McKinley Monument. Cancelled 1911, divided back, $3-5.
The postcard reads: *"November 14, 1911, To Grandpa Leege (Wisconsin): Well winter days are here again. I suffer. You won't have a chance to go outdoors again for a few months. Best wishes, Will."*

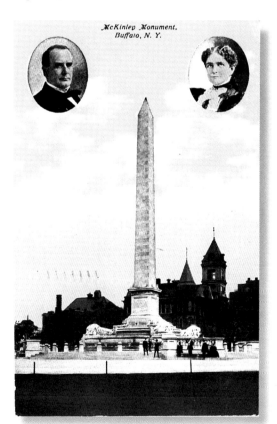

McKinley Monument. President William McKinley was assassinated while attending the Pan-American Exposition in 1901. Circa 1900s, undivided back, $4-6.

MCKINLEY MONUMENT, BUFFALO, N.Y.

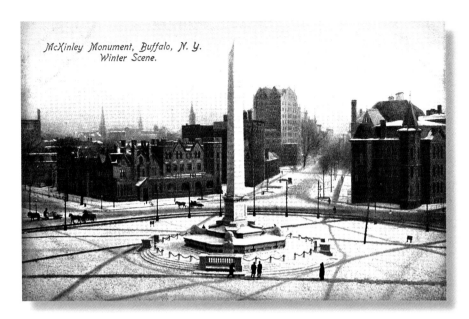

McKinley Monument, Buffalo, N.Y. Winter Scene.

McKinley Monument. Winter Scene. The monument is a Buffalo landmark. Circa 1900, undivided back, $3-5.

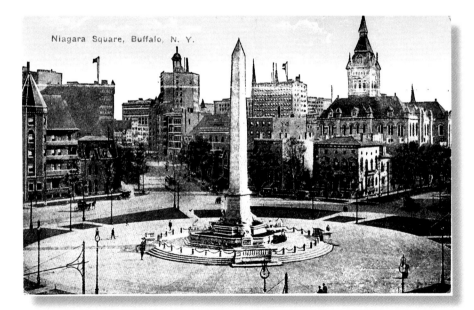

Niagara Square, Buffalo, N.Y.

Looking down Niagara Street from Main Street, showing the McKinley Monument. Circa 1920s, divided back, $4-6.

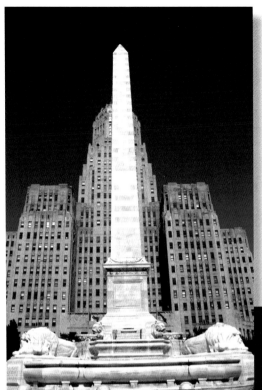

The monument was erected in 1907.

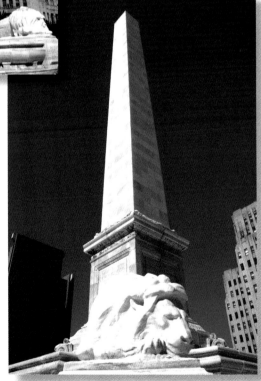

24

Soldiers & Sailors' Monument:

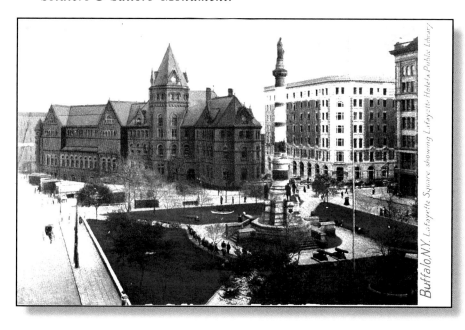

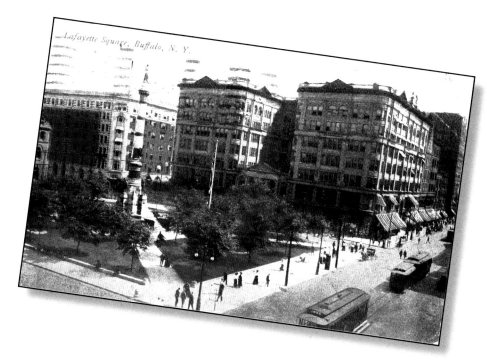

Lafayette Square, showing the Soldiers & Sailors Monument. Circa 1910s, divided back, $3-5.

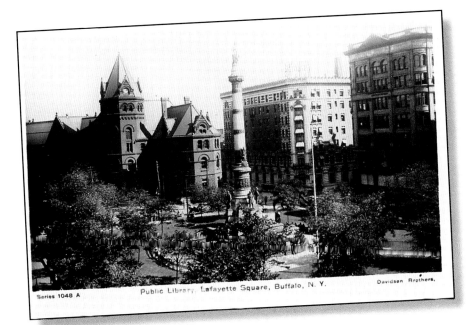

Lafayette Square. Cancelled 1912, divided back, $3-5.
The back of the postcard reads: *"June 19, 1912, Miss Ida Geaheeler, Ohio: Don't know if you can guess from whom this is or not. Am in Buffalo today. in Michigan soon & then to Rochester N.Y."*

Lafayette Square showing the Lafayette Hotel & Public Library. This Public Library, completed in 1887, was located where the new Erie County Library now stands. Circa 1900s, undivided back, $3-5.

25

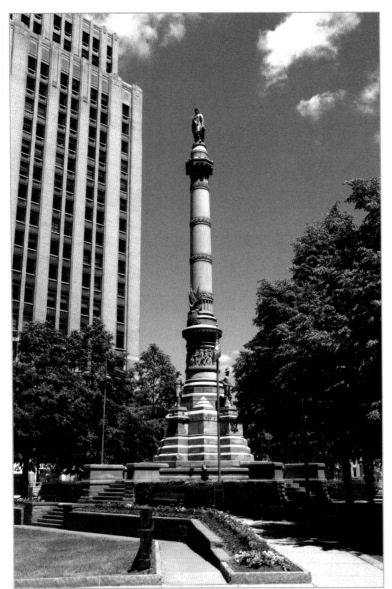 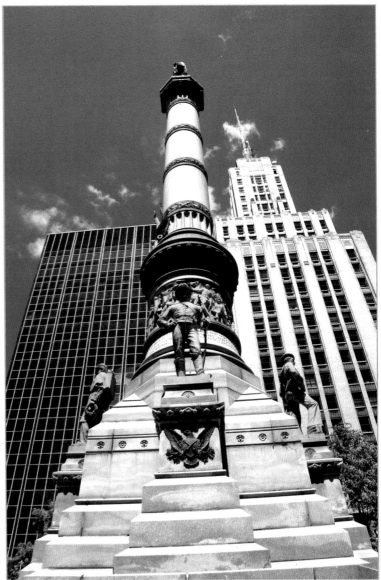

The Soldiers and Sailors Monument was built in 1882.

Public Buildings

"Buffalo, situated at the foot of Lake Erie, in the northwest part of the State of New York, is a well-built city, and contains 35,000 inhabitants. It has all been built within the last thirty-six years, and owes its prosperity to its favorable situation, and its harbor, which is capable of containing 1,000 sail of vessels of all descriptions. About one hundred steamers enter and depart daily, and the docks are as well thronged with warehouses, merchandise, drays, and laborers, as those of any port or city in America. It is the great entrepôt of the produce of the western parts of Pennsylvania, Ohio, Indiana, Illinois, Michigan, and Wisconsin, besides a great traffic to Canada and Lake Superior. Main street in Buffalo is the finest of any out of New York, and the inns are as large and as numerous as in any city of the world, the influx of travelers brought to this city by the canals, railway, stages, and private wagons every day being enormous; indeed, it is calculated that for seven months in the year at least five thousand persons pass through on their way to the west every day." — *William Leeds Brown, traveler, "America: A Four Years' Residence in the United States & Canada, 1849*

Buffalo City Hall:

"The City of Buffalo. Looking across Niagara River from the crumbling ruins of Fort Erie, whose most frequent visitors today are the cows of the neighboring farmers browsing peacefully on the grass-grown ramparts, whence seventy years ago General Peter B. Porter made his brilliant sortie, one sees the granite tower of the City Hall of Buffalo rising commandingly above the surrounding miles of warehouses and factory chimneys, hooded in an atmosphere of smoke and steam. Northward, past the high bluff, crowned by the ruins of Fort Porter and the stone copings of The Front, flows the Niagara with a constantly accelerating velocity. Parallel with it, packed with long lines of freighted boats towed by slow-paced horses, is the Erie Canal." — *The City of Buffalo (Harper's new monthly magazine), Vol. 71, Issue 422, July 1885.*

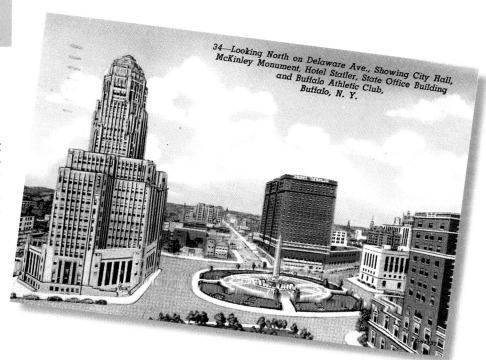

Looking north on Delaware Avenue, showing City Hall, McKinley Monument, Hotel Statler, State Office Building and Buffalo Athletic club. Cancelled 1940, divided back, $3-5.
The postcard reads: *"November 22, 1940, To James Sawyer, NYC: Getting ready to go to the banquet at 6:30. See you Wednesday."*

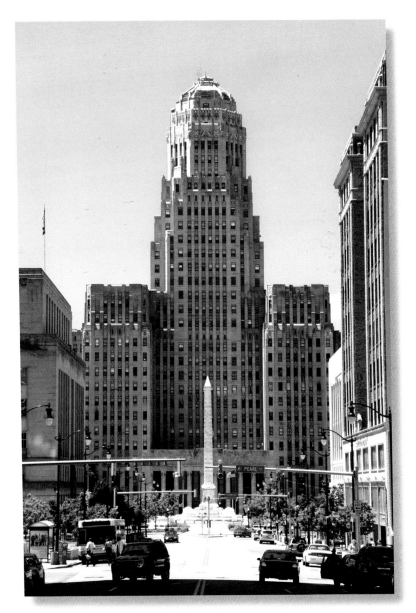

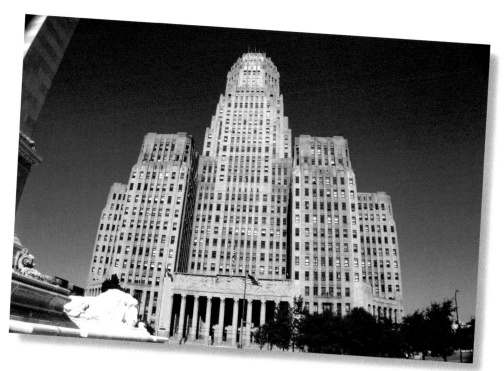

The building was erected between 1929 and 1931.

Buffalo City Hall is located at 65 Niagara Square. Tours of City Hall are held daily. City Hall is a Buffalo landmark and is on the National Register of Historic Places.

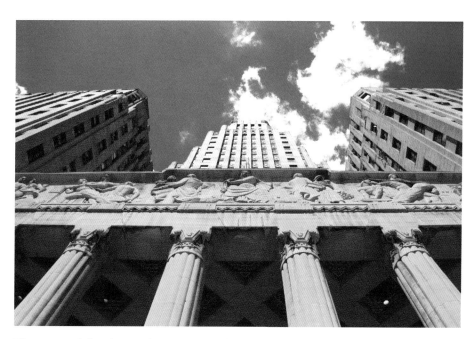

There are eight giant columns by the front entrance. The friezes above represent aspects of the city's cultural and economic life.

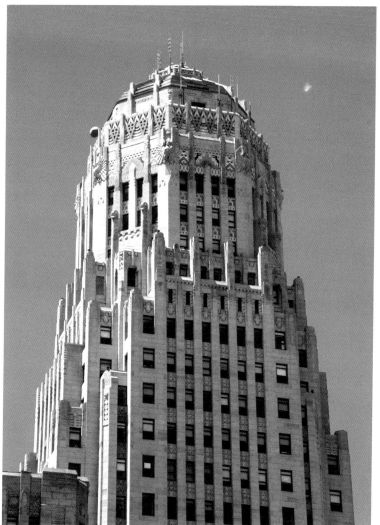

A detail of the top of the building. There is a lookout on the floor and weekly tours are conducted from the building at noon each day. The observation deck on the twenty-fifth floor offers breathtaking views of the city.

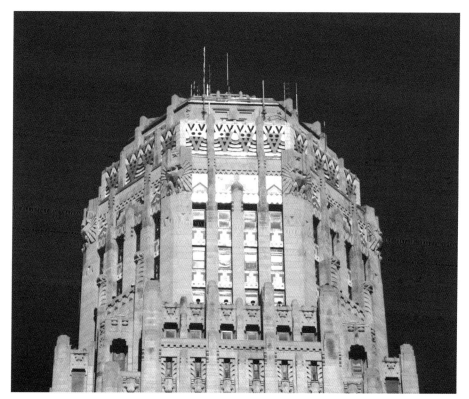

A close up of the building.

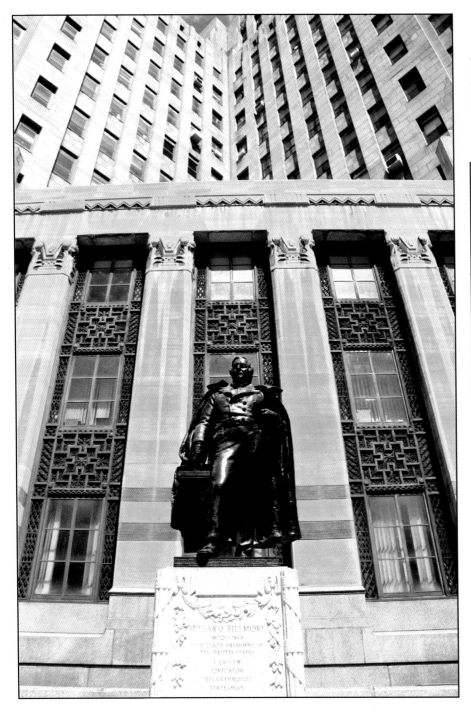

The Millard Fillmore bronze statue. Millard Fillmore was a resident of Buffalo in 1822 before he became America's thirteenth president.

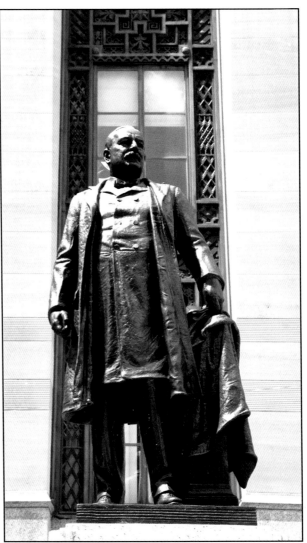

Millard Fillmore was elected and inaugurated on June 9, 1848, and after the death of President Taylor, he became president on July 10, 1850.

Erie Community College:

"On leaving Niagara, I proceeded to Buffalo, 22 miles by railway, from the cars on which you have a beautiful view of the river Niagara the whole way. Buffalo is finely situated on the outlet of Lake Erie, at the head of Niagara river, and will soon be a magnificent place, as from its situation it commands the whole trade of the four great Western Lakes; Superior, Michigan, Huron, and Erie. It has had a most extraordinary rise, having been laid out in 1801."

"In the year 1825, the population was only 2,412; whereas, at the present moment, it is estimated at 80,000, several thousands of whom are Germans. The German correspondence is so extensive, that a separate bureau is established at the post office for German letters. The principal street, called Main Street, is one of the finest in the world, being three miles long and 120 feet broad; four feet broader than Broadway, New York. This street rises with a gentle acclivity from Buffalo Creek, and at its summit height, sixty or seventy feet above the level of Lake Erie, you have a magnificent view of that Lake and the Canadian shore on the opposite side of the river Niagara which presents the appearance of a dense mass of forest, as far as the eye can reach." — *Alexander Majoribanks, "Travels in South and North America," 1854*

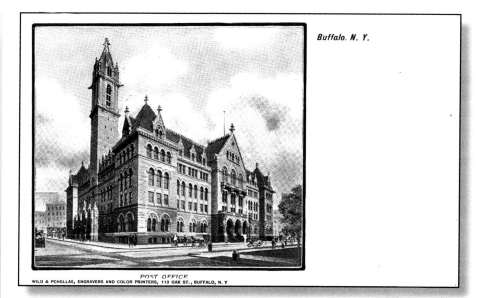

Buffalo. N. Y.

POST OFFICE
WILD & PCHELLAS, ENGRAVERS AND COLOR PRINTERS, 113 OAK ST., BUFFALO, N.Y

The post office is now the home of Erie Community College. Originally not only the post office was housed in this building, but also other government agencies including the customs office, Bureau of Internal Revenue etc. Cancelled 1905, undivided back, $3-5. *Source: Library of Congress HABS, New York.*

The college is located at 121 Ellicott Street, Circa 1910s, divided back, $3-5.

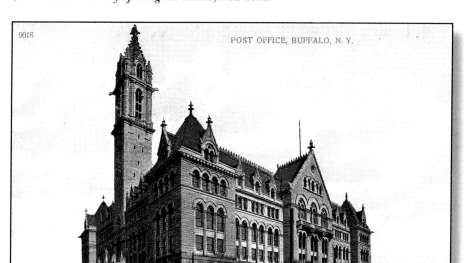

9018
POST OFFICE, BUFFALO, N. Y.

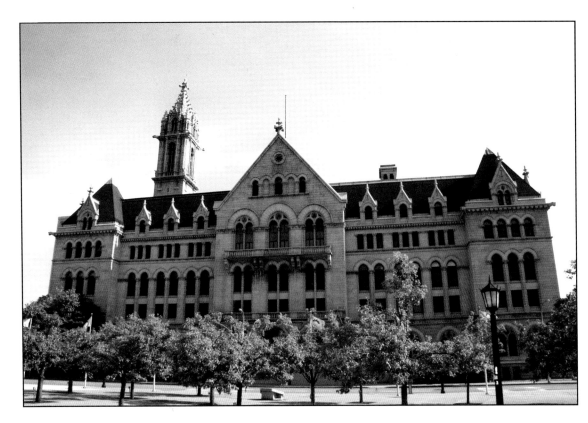

The building is on the National Register of Historic Places.

Look closely at the tower for the gargoyles.

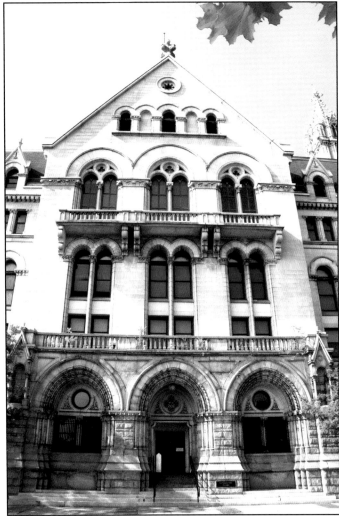

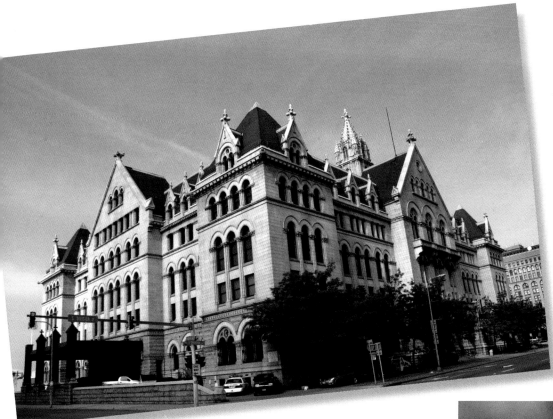

Actual excavation of the site began in 1894, but the building was not ready until 1901.

This shot shows the rear exterior of the building.

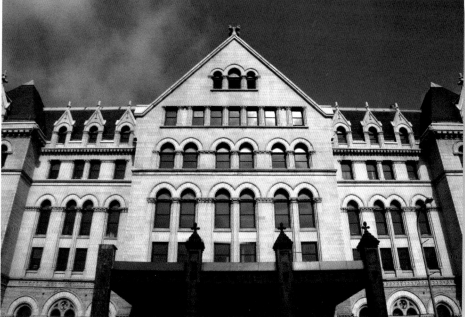

Federal Court House:

"I went into the Court House in Buffalo during the sessions, and was much struck by the proceedings. There were three judges upon the bench (a president and two assistants). A most infernal looking scoundrel was upon his trial for robbery, and the counsel for the defence(sic) always alluded to his client as the 'gentleman' at the bar. The counsel wore neither wigs nor gowns, and, as well as the judge, being dressed in plain clothes, it to my thinking more like a town's meeting at our Leeds Court House, than anything I could liken it to. The barristers all chewed tobacco, just as unceremoniously as the spectators, and were sat with their heels upon the backs of the nearest chairs, squirting out the tobacco juice upon the floor, which was almost covered in all vacant places with the unseemly expectorations." — *William Brown Leeds, "America: A Four Years' Residence in the United States and Canada," 1849*

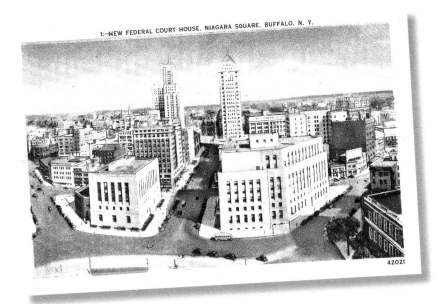

New Federal Court House, Niagara Square. It was dedicated in 1937 by President Franklin Roosevelt. Circa 1930s, divided back, $4-6.

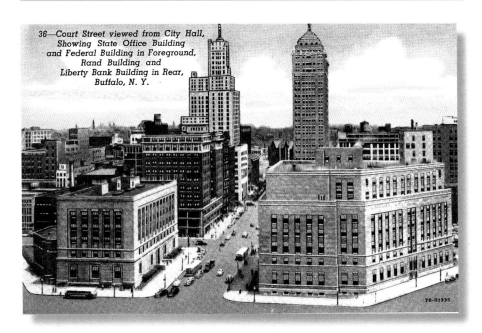

Court Viewed from City Hall, showing the State and Federal office buildings in foreground, and the Rand building and Liberty Bank building in Rear. Circa 1940s, divided back, $3-5.

The City Court House is now located on Delaware Avenue.

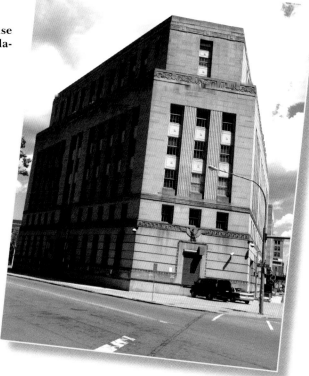

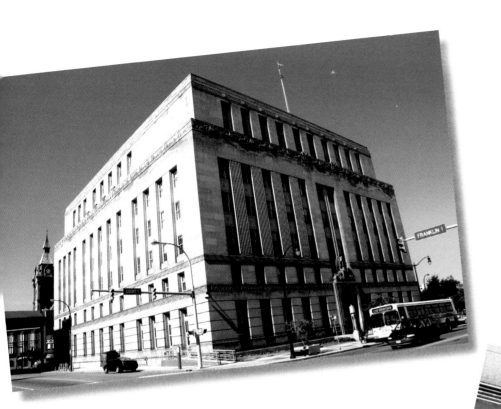

Federal Courthouse, Buffalo. The building is currently used by the United States Post Office.

The Old Federal Courthouse is located at 64 Court Street.

The Old Federal Courthouse was built in 1936.

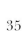

Old County Hall:

"Buffalo doesn't seem to be ambitious of display in her public buildings, judging from the quality of those already on hand. The new City Hall, however, is a noble exception to the general rule. It is built of Maine granite, in the form of a double Roman cross, and the tower, which is two hundred and forty-five feet high, is surmounted by four pieces of statuary. It is estimated cost is over two millions of dollar!" — *Willard W. Glazier, traveler, "Pecularities of American Cities," 1886*

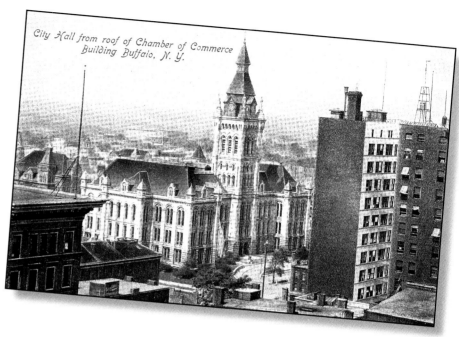

City Hall. Now known as Old County Hall, it was built between 1871 and 1876. Circa 1900s, undivided back, $4-6.

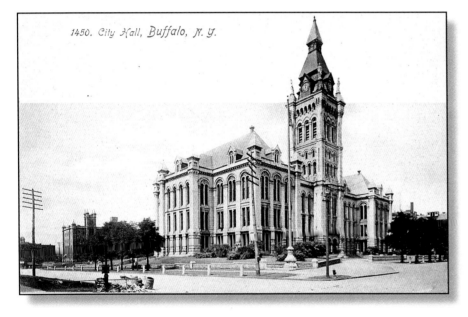

City Hall from the roof of the Chamber of Commerce Building. Circa 1910s, divided back, $3-5.

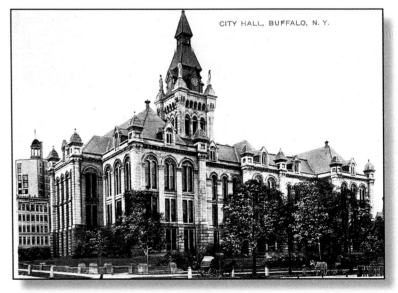

City Hall. Circa 1910s, divided back, $3-5.

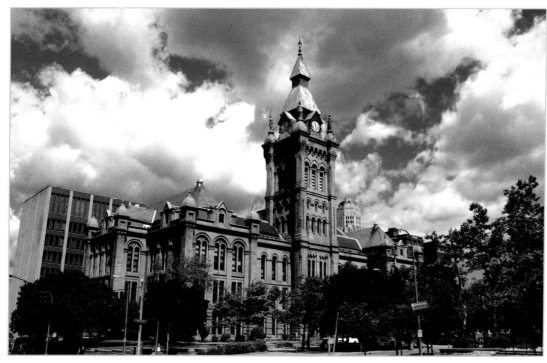

At the top of the building are four statues representing Justice, Mechanical Arts, Agriculture, and Commerce.

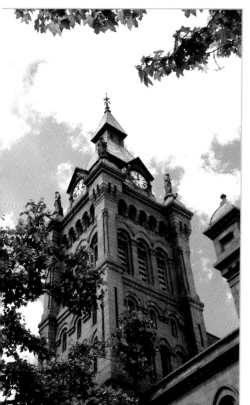
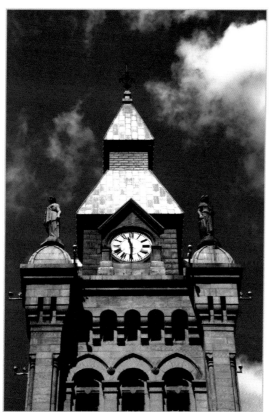
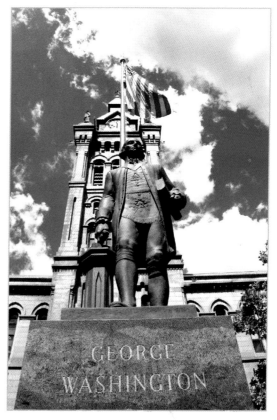

Far left:
Old County Hall is located at 95 Franklin Street. The building is on the National Register of Historic Places.

Center:
The bell tower is 268 feet high.

Left:
The George Washington statue.

Buffalo's Other Buildings

The Dun Building:

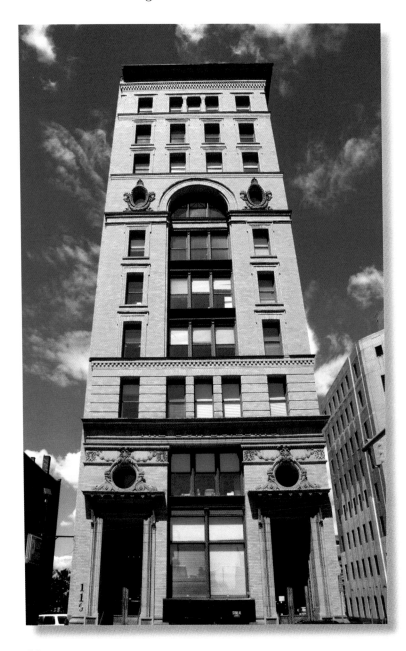

The building—a Buffalo landmark—is located at 110 Pearl Street.

The Dun Building was built between 1894-1895. The site was home to Buffalo's first school in 1807 and was burned by the British in 1813.

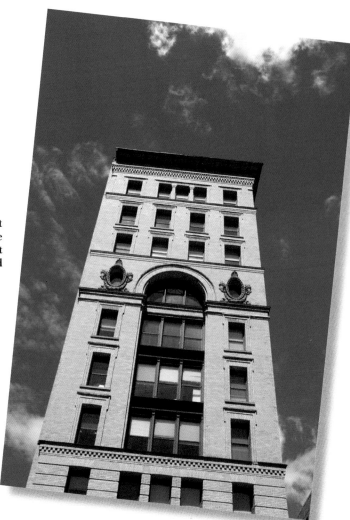

The Brisbane Building:

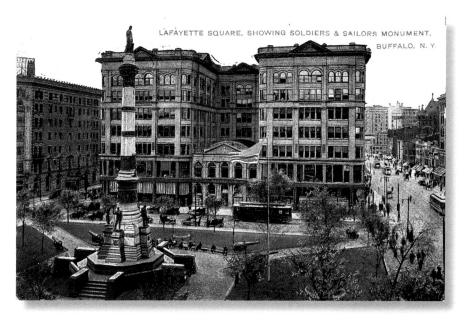

Lafayette Square, showing Soldiers & Sailors Monument.
Circa 1910s, divided back, $3-5.

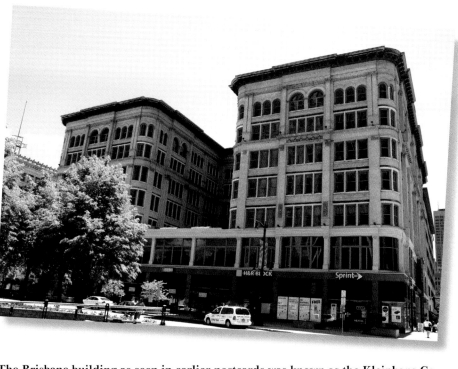

The Brisbane building as seen in earlier postcards was known as the Kleinhans Co.
Men's Clothing Store. The store operated for ninety-seven years.

The Brisbane building is located at 403
Main Street. It was build between 1893
and 1894.

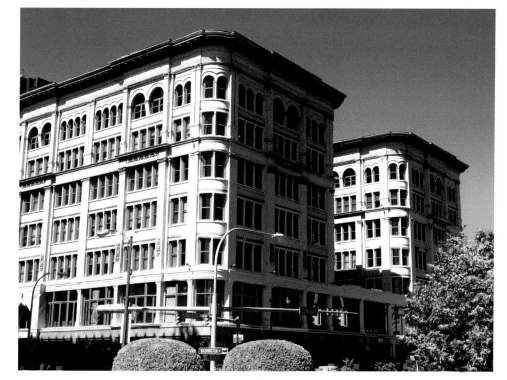

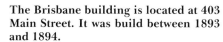

Dunn Tire Park:

"A seat was pointed out to me, and I was presented with a large bag of pea-nuts, which I was seriously informed were the correct things to eat on such an event as this…But the ball game, the great national game of America, was in full swing, and I was there to view it for the first time, in the private box of the President of the Club, surrounded by friends of all ages who were as enthusiastic as children at their first school treat. They did not seem able to sit still a minute. They cheered and shouted themselves hoarse at every turn of the game. They punched me on the back to emphasize a clever hit or throw, unfortunately almost invariably when I was about to swallow an extra large portion of pea-nut." — *Nicholas Everitt, "Round the World in Strange Company," 1915*

Dunn Tire Park opened in 1988.

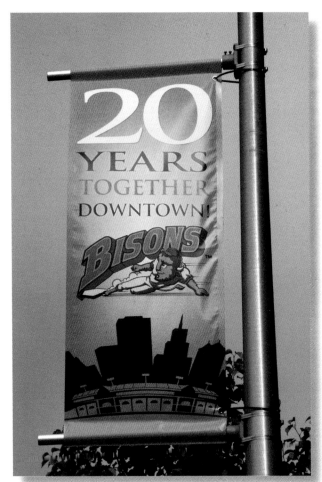

Home of the Buffalo Bissons.

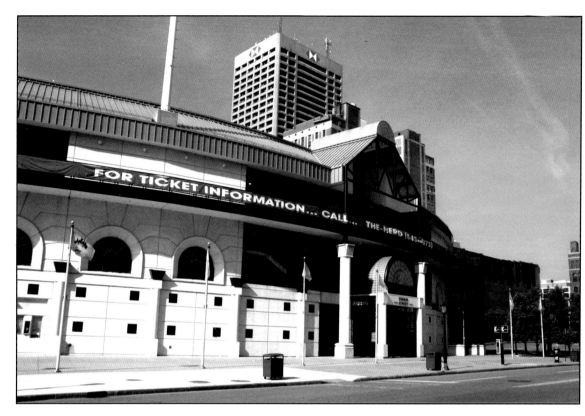

The park is located at 275 Washington Street.

In 2007 the Buffalo Bison hosted seventy-two games so the chances of catching a game during your trip to Buffalo are good.

Ellicott Square Building:

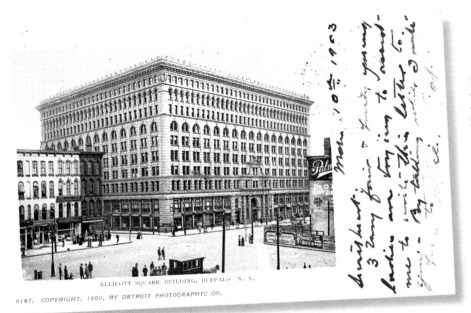

Ellicott Square Building. In 1896 it was the largest office building in the world. Circa 1900s, undivided back, $4-6.

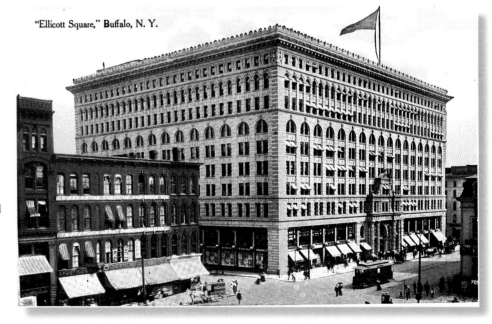

Ellicott Square Building. Cancelled 1903, undivided back, $4-6.

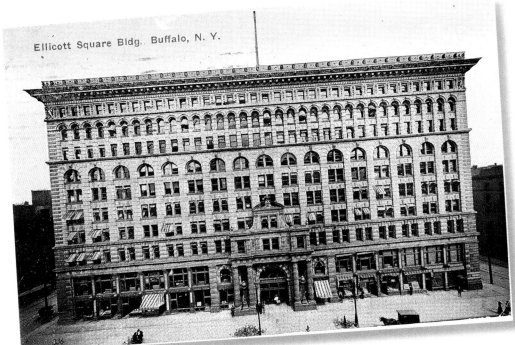

Ellicott Square Building.
Cancelled 1915, divided
back, $3-5.

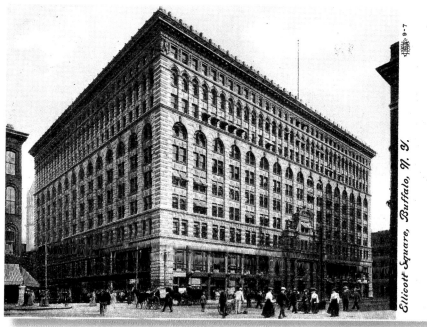

Ellicott Square Building. Circa
1910s, divided back, $3-5.

43

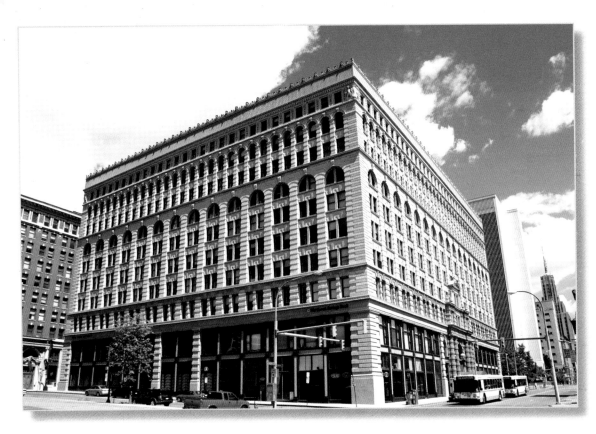

The Ellicott Square Building is located at 295 Main Street.

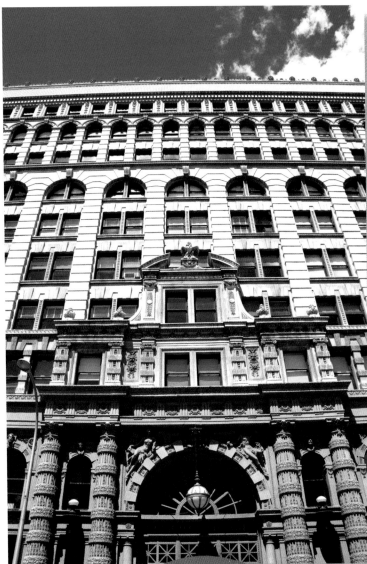

The Ellicott Square building was the largest office building in the United States when it was completed.

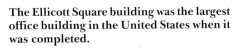

44

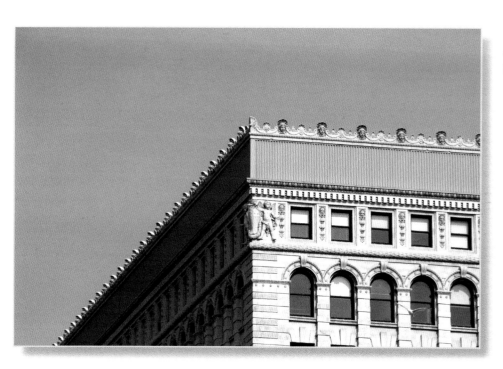

The building was erected
between 1895-1896.

A detail of the
elaborate exterior.

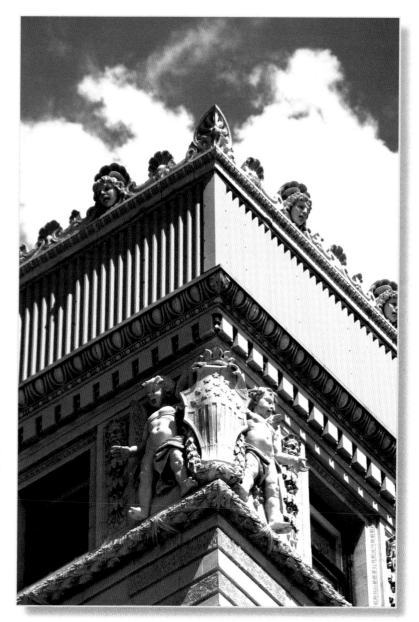

45

The Guaranty Building:

"I seemed to be shot up, like a bullet from a rifle, to the top of a Buffalo skyscraper, and I found myself ushered into the office of the friend who had taken me in tow…I smoked in silence and had ample leisure to survey my surroundings. I was in a private office at the top of a lofty building. Large windows opened out on two sides, one enabling a survey of the street below, where the traffic and pedestrians looked much like the sight one sees when gazing down on to a busy ant heap; other windows gave magnificent views of Lake Erie, upon the shores of which Buffalo is built." — *Nicholas Everitt, traveler, "Round the World in Strange Company," 1915*

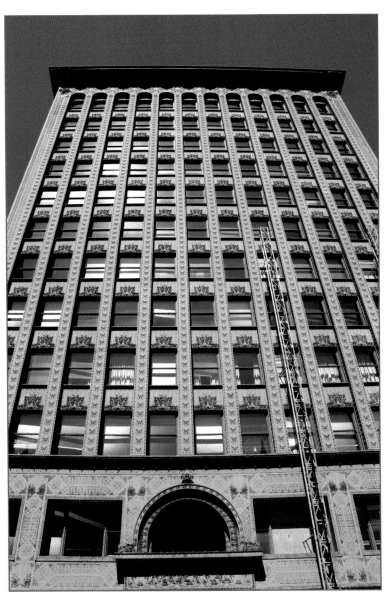

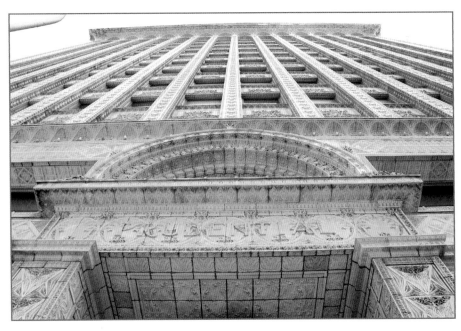

The Guaranty Building has thirteen floors.

The Guaranty Building is located at 28 Church Street. It is also known as the Prudential Building.

The Guaranty building is a Buffalo Landmark, a National Historic Landmark, and on the National Register of Historic Places.

The building was erected between April 1895 and April 1896.

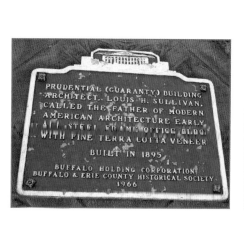

The Liberty Building:

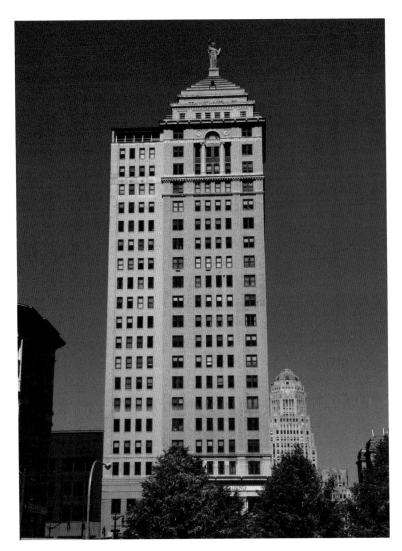

The Liberty building is located at 424 Main Street.

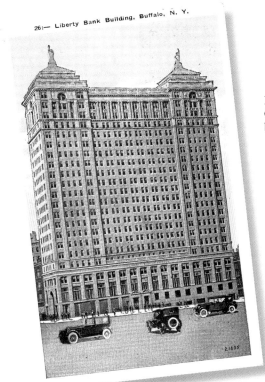

Liberty Bank Building. Cancelled 1923, divided back, $4-6.

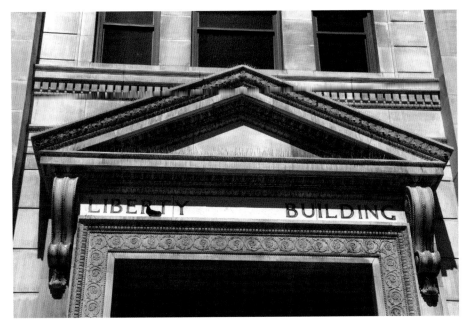

The building was erected in 1925.

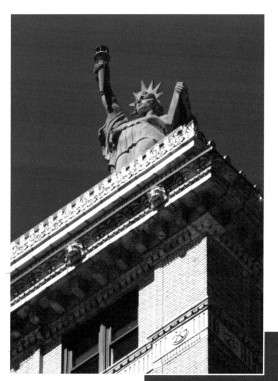

The two statues on top of the building are replicas of Bartholdi's Statue of Liberty.

The L.L. Berger Building:

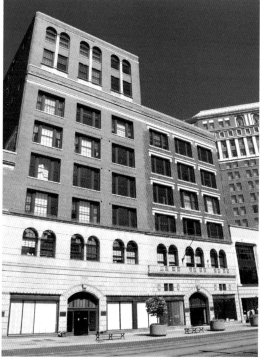

The L.L. Berger Building is located at 514 Main Street. The L.L. Berger retail chain was considered the fashionable store for women at one time.

The building dates to 1929.

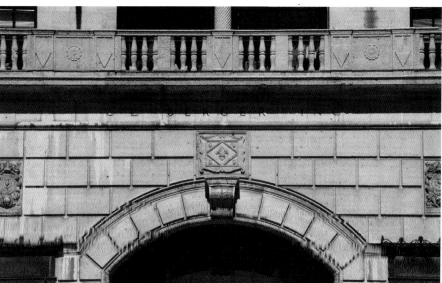

The Market Arcade:

"The markets at Buffalo are well supplied with fish, flesh, and fowl. The price of a quarter of lamb, weighing about 5 lbs. was 25 cents, or 1s. sterling, and every other article was in the same ratio." — William Leeds Brown, "America: A Four Years' Residence in the United States," 1849

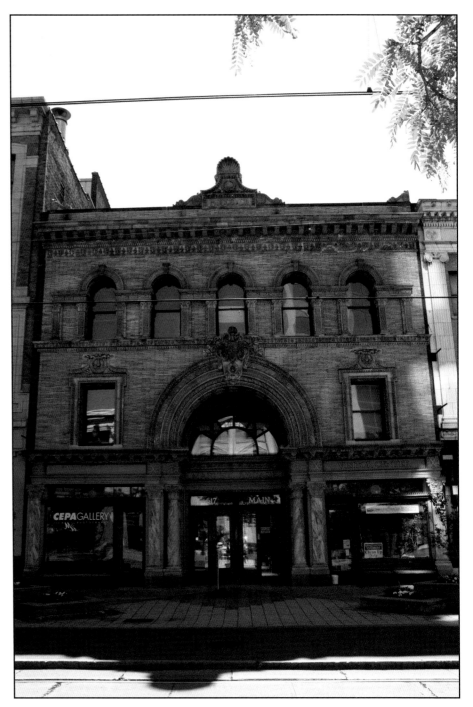

The Market Arcade is located at 617 Main Street. For many visitors to Buffalo this will be their first place after coming off the freeway as it is home to the Buffalo-Niagara Visitors Center.

The building was originally called Palace Arcade. The arcade was used as a thoroughfare from Main Street to the Chippewa market.

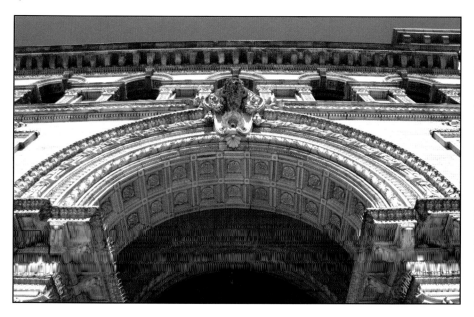

Market Arcade was built in 1892. It is a Buffalo landmark.

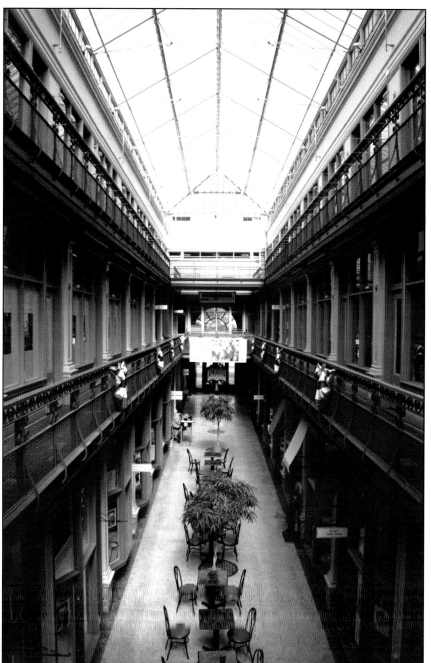

The interior of the arcade.

M & T Bank (Buffalo Savings Bank):

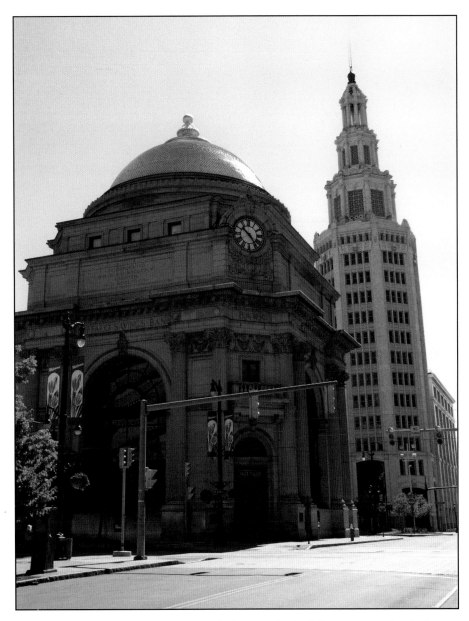

The M & T Bank is located at 545 Main Street. The building was previously known as the Buffalo Savings Bank. The bank is a Buffalo landmark.

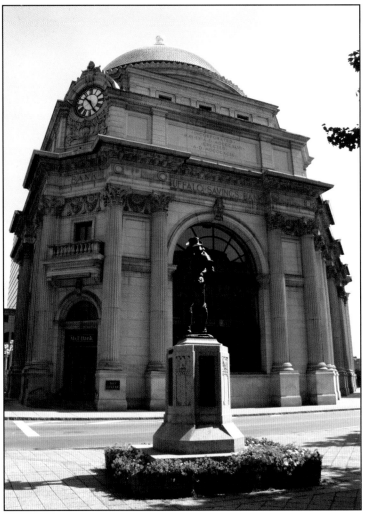

The statue titled "The Hiker," commemorating the armed forces that served during the Spanish-American War, is adjacent to the bank.

The roof has been gilded with gold three times.

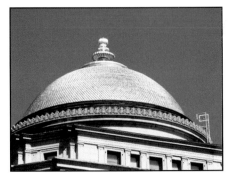

The Niagara Mohawk:

"The sight by night: The Exposition was well worth seeing in parts by day and as whole by night. The electrical display at night was a triumph of engineering skill and architectural arrangement. It was the falls of Niagara turned into stars, the mist of the mighty cascade crystallized into jewels, a brilliant crown to man's triumph over the forces of nature. It was a wonderful and never-to-be-forgotten sight to sit by the waters at night, as the shadows were folding the buildings in their soft embrace, and see the first faint twinklings of the thousands upon thousands of lights as the great current of electricity was turned slowly on; and then to see the lights grow in strength until the entire grounds were bathed in suffused radiance—that was as wonderful a sight as the world of electricity has yet witnessed, and it was well worth crossing an ocean to see; it was the one conspicuous success, the one memorable feature of the Exposition, and compared with it all exhibits and scenes by day were tame and insipid." — *Arthur Jerome Eddy, traveler, "Two Thousand Miles on an Automobile," 1902*

The Electric Building, now known as the Niagara Mohawk Building, is a Buffalo landmark. Circa 1920s, divided back, $4-6.

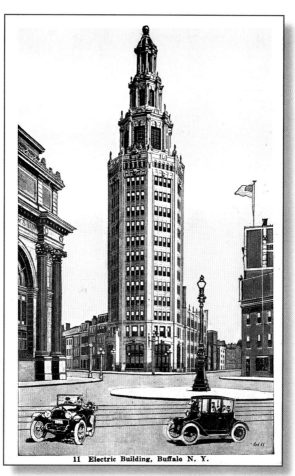

11 Electric Building, Buffalo N. Y.

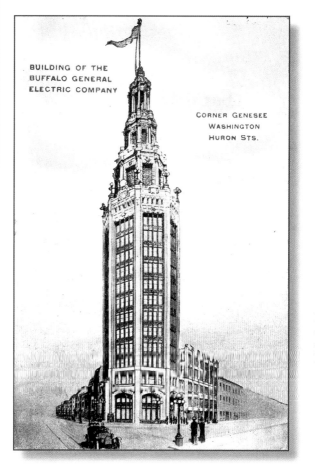

BUILDING OF THE BUFFALO GENERAL ELECTRIC COMPANY

CORNER GENESEE WASHINGTON HURON STS.

Building of The Buffalo General Electric company, Corner of Genesee, Washington, and Huron streets. Cancelled 1911, divided back, $1-6.

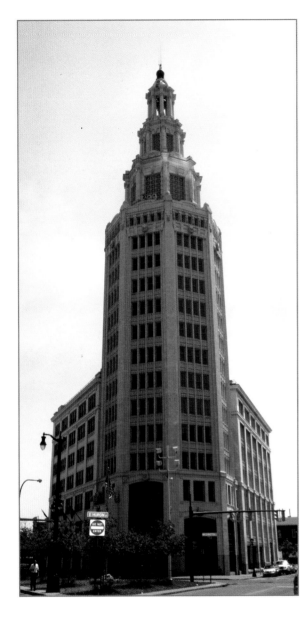

The building is considered to be one of Buffalo's most recognizable landmarks.

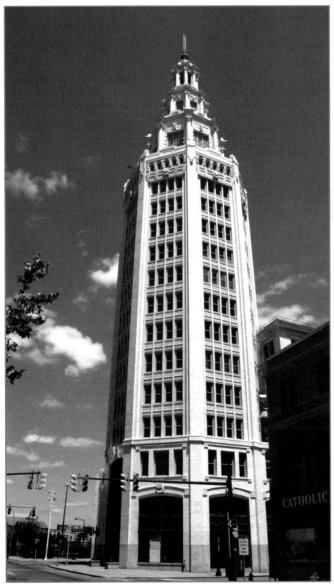

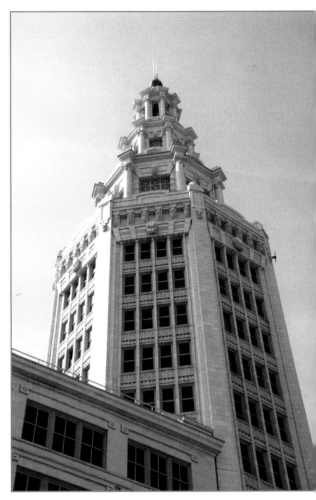

It was built between 1900-1901.

The building is located at 535 Washington Street.

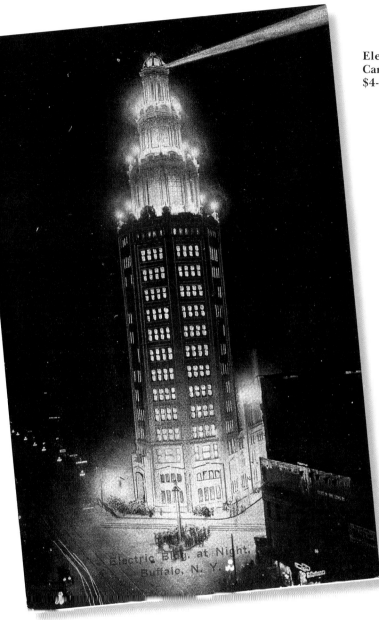

Electric Building at Night.
Cancelled 1911, divided back,
$4-6.

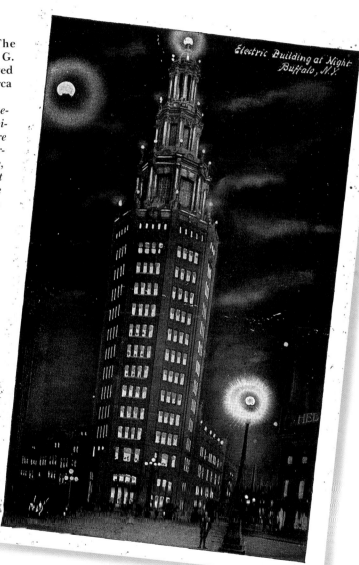

Electric Building at Night. The building was inspired by John G. Howard's electric tower, which awed crowds at the 1901 exposition. Circa 1920s, divided back, $4-6.

"Housing the machine in a convenient and well-appointed The Exposition stable for automobiles, we were reminded of the fact that we had arrived in Buffalo at no ordinary time, by a charge of three dollars per night for storage, with everything else extra. But was it not the Exposition we had come to see? And are not Expositions proverbially expensive— to promoters and stockholders as well as visitors?" Arthur Jerome Eddy, *"Two Thousand Miles on an Automobile; Being a Desultory of a Trip through New England, New York, Canada, and the West,"* 1902.

The Stanton Building:

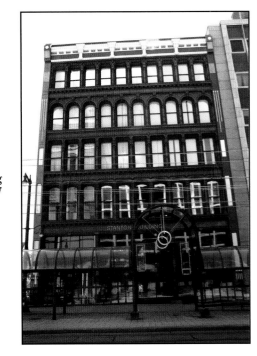

The Stanton building is located at 251-257 Main Street.

One M & T Plaza:

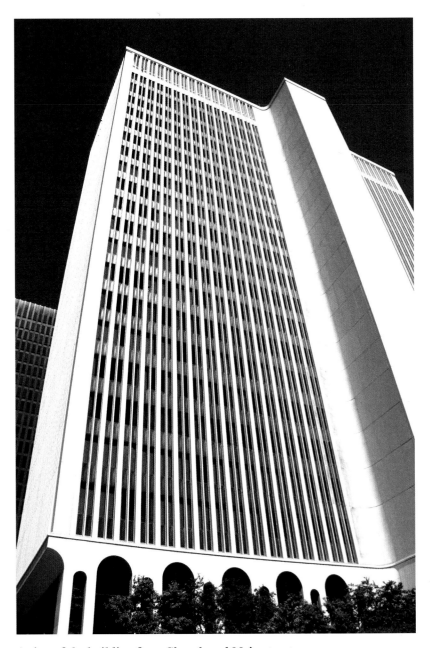

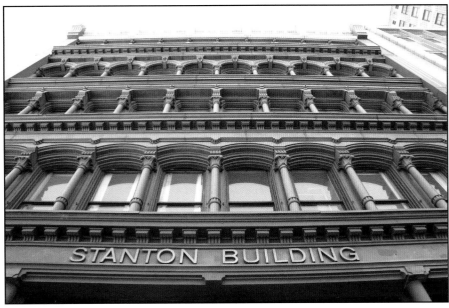

In some architectural guides it is listed as the Dennis Building. The front of the building is made entirely of iron.

A view of the building from Church and Main streets.

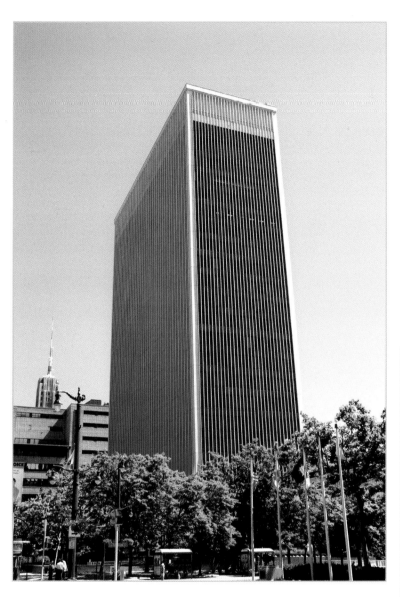

The building as it's viewed from Main Street.

The Bertoia fountain in the front plaza.

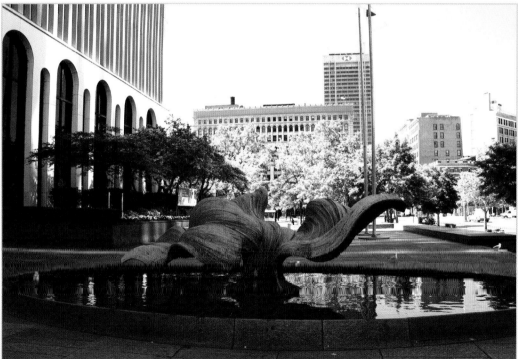

The Ticor Title Building:

"In the afternoon we crossed the river again, and went by railroad to Buffalo, on Lake Erie, about twenty miles from the Falls. The town is well worth seeing; and its history is curious and characteristic. It is not above twenty years old, yet it contains (I believe) 18,000 inhabitants, and covers a vast extent of ground. It was created by the Erie canal, which connects the ocean with Lake Erie (through the Hudson); and consequently this port is the depot for all the commerce of the north-west. Great part of the town, including the best public buildings, was erected by a Mr. Rathbun, whom you may call an able financier, or an enormous rogue, according to your notions of talent and morality. He started without any capital at all, bought lands, built streets, and had sometimes a thousand workmen in his employment. The funds were supplied by a most daring and gigantic system of forgery..." — *John Robert Godley, traveler, "Letters from America," 1844*

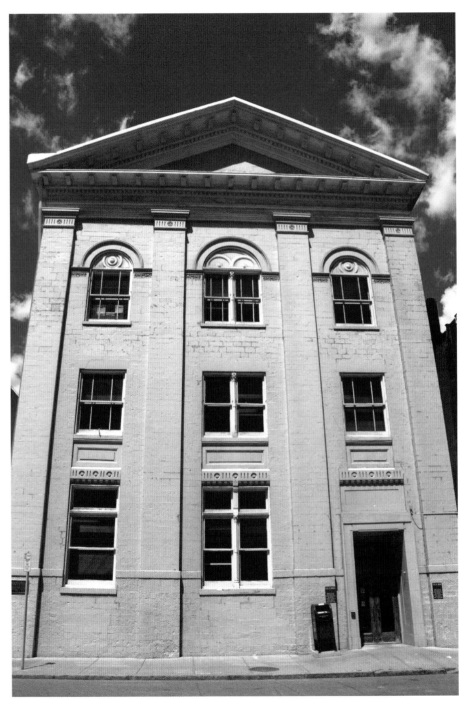

The Ticor Title building was built in 1833. This is a view of the building from Franklin Street.

Benjamin Rathbun was responsible for the construction of this building. By 1835, he had built ninety-nine buildings in Buffalo, but it was later discovered he owed $1.5 million in forged notes.

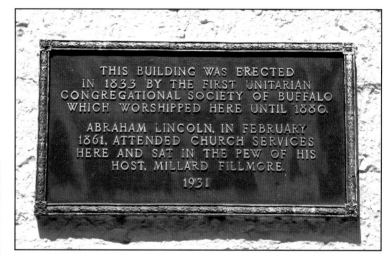

THIS BUILDING WAS ERECTED IN 1833 BY THE FIRST UNITARIAN CONGREGATIONAL SOCIETY OF BUFFALO WHICH WORSHIPPED HERE UNTIL 1880.

ABRAHAM LINCOLN, IN FEBRUARY 1861, ATTENDED CHURCH SERVICES HERE AND SAT IN THE PEW OF HIS HOST, MILLARD FILLMORE.

1931

The building was first used by the First Unitarian Church. This plaque commemorates Abraham Lincoln's visit to the church.

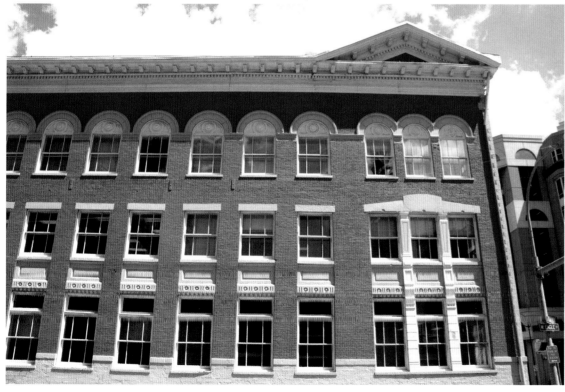

The view from Eagle Street.

The YMCA Building:

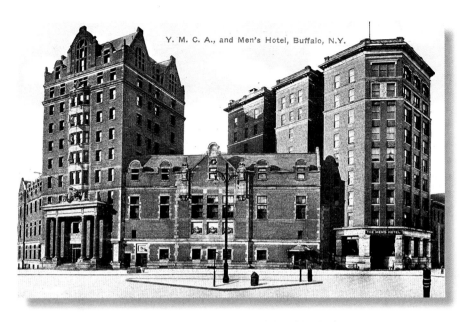

Y. M. C. A., and Men's Hotel, Buffalo, N.Y.

The YMCA and Men's Hotel. Circa 1930s, undivided back, $3-5.

The main entrance of the YMCA now faces the Buffalo Convention Center. Originally it would have fronted onto present-day Genesee Street.

The official plaque.

1852
YOUNG MEN'S
CHRISTIAN
ASSOCIATION
1902

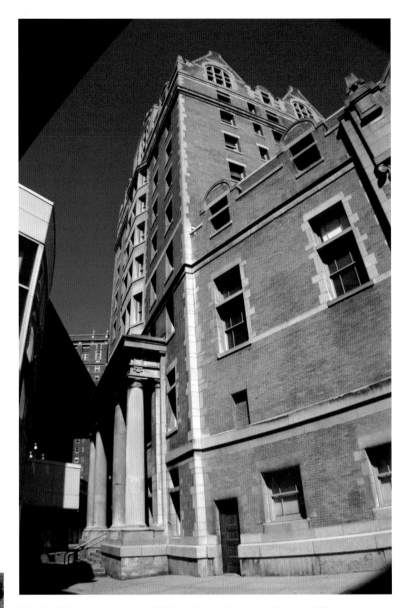

The YMCA is located at 45 West Mohawk Street. The building is on the National Register of Historic Places

Churches

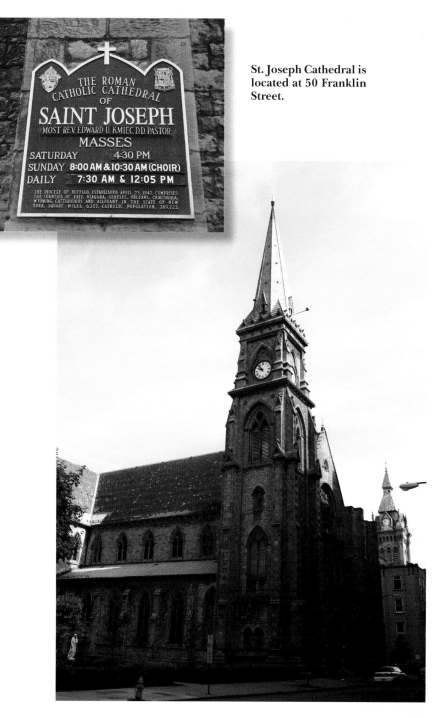

St. Joseph Cathedral is located at 50 Franklin Street.

St. Joseph Cathedral:

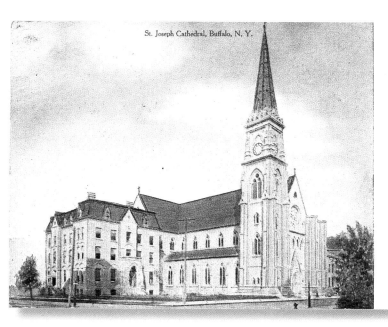

St. Joseph Cathedral, Buffalo, N. Y.

St. Joseph Cathedral. This Buffalo landmark was constructed between 1851 and 1855 and later renovated in the mid-1970s. Cancelled 1909, divided back, $3-5.

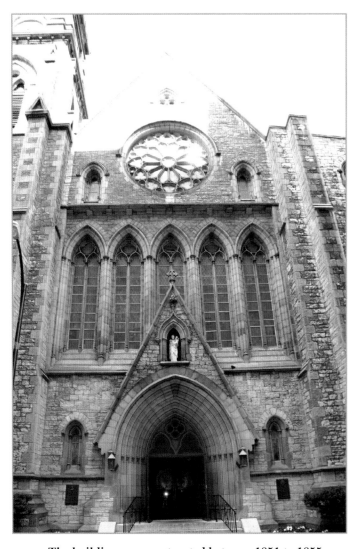

The building was constructed between 1851 to 1855.

Below & right:
The niche above the central doorway.

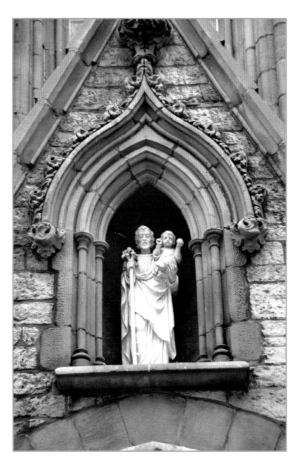

St. Paul's Episcopal Church:

"As one approached the Terrace, which is an elbow of blocks at one end and a diagonal at the other one is confronted by a confusion of cross streets, which look as if they had been gotten up expressly to demoralize one's points of compass...In one triangular piece of ground where the three streets of Niagara, Erie and Church make their entrance into Main Street, stands the picturesque structure of St. Paul's Episcopal Cathedral. It is built of brown stone, and the creeping ivy nearly covers one end of it, from the crosses and minarets at the pinnacle to the trailing vines on the ground." — *Willard W. Glazier, "Pecularities of American Cities," 1886*

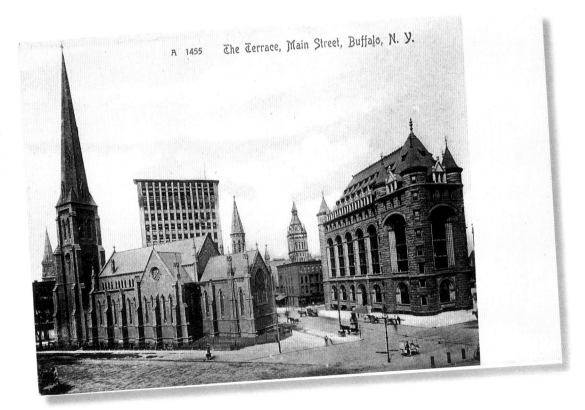

The Terrace, Main Street. St Paul's Episcopal Church is shown in the foreground. The Guaranty Building is behind it and the now demolished Erie Savings Bank is to the right. The church was originally constructed between 1851-1852. It was rebuilt after a fire struck in the late 1800s. Circa 1900, undivided back, $4-6.

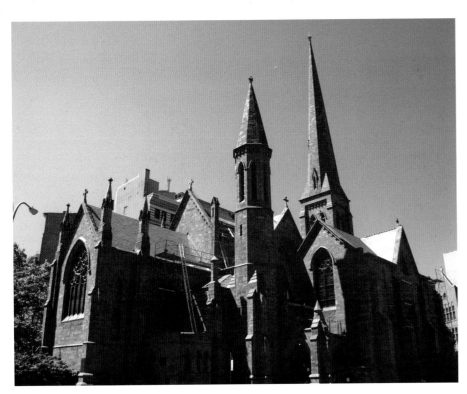

Saint Paul's Cathedral is located at 125 Pearl Street.

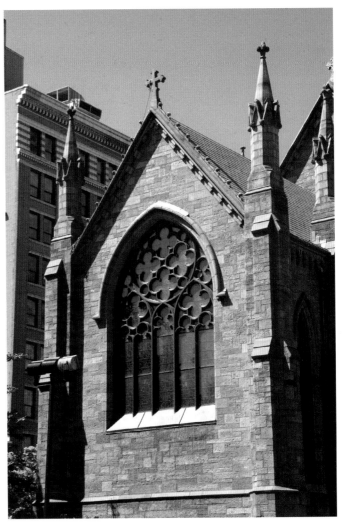

The cathedral is on the National Register of Historic Places.

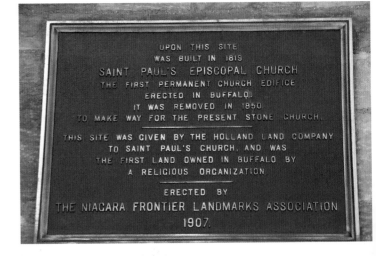

UPON THIS SITE
WAS BUILT IN 1819
SAINT PAUL'S EPISCOPAL CHURCH
THE FIRST PERMANENT CHURCH EDIFICE
ERECTED IN BUFFALO.
IT WAS REMOVED IN 1850
TO MAKE WAY FOR THE PRESENT STONE CHURCH.

THIS SITE WAS GIVEN BY THE HOLLAND LAND COMPANY
TO SAINT PAUL'S CHURCH, AND WAS
THE FIRST LAND OWNED IN BUFFALO BY
A RELIGIOUS ORGANIZATION.

ERECTED BY
THE NIAGARA FRONTIER LANDMARKS ASSOCIATION
1907.

Hotels & Clubs

"The squares and streets of Buffalo are planned upon an extensive scale, and the buildings are pretty good. The Eagle Hotel, that at which we took up our quarters, is not only very large, but is equal in most respects to the best in Great Britain. Nearly one hundred persons of both sexes sat down to meals, most of whom were store-keepers and their assistants. The females were first shown to their usual station, the upper end of the long table, and then came the eager rush of hungry 'business men,' summoned from all parts of the village by the great alarm bell fixed on the summit of the building. We invariably noticed, that the American females had delicate appetites, and ate very little, although they permitted their plates to be loaded unmercifully, seldom refusing any thing, however opposite in taste." — *James Borden, traveler, "America & the Americans: Be A Citizen of the World," 1833*

The Hyatt Hotel:

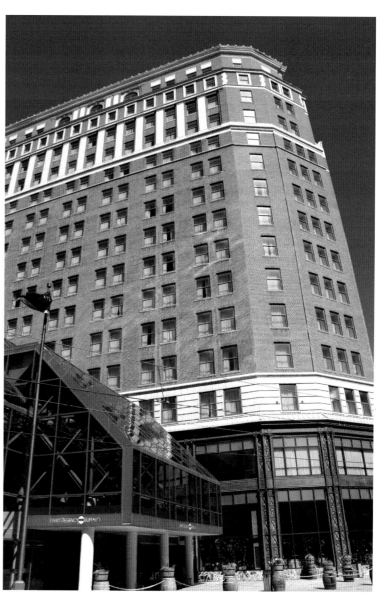

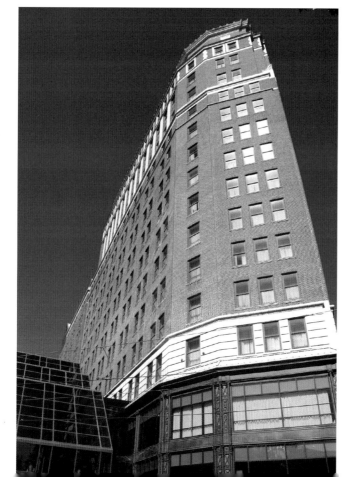

The Hyatt Hotel is located at 2 Fountain Plaza. It was known as the Genesee Building. The eleven-story tower was built in the 1980s.

The hotel was formerly an office building built between 1922-1923.

The Lafayette Hotel:

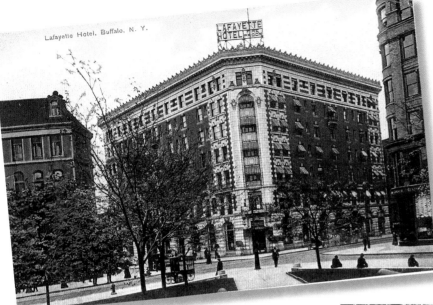

The Lafayette Hotel was built in 1904 and designed by Louise Bethune. Circa 1910s, undivided back, $3-5.

The Lafayette Hotel is located at 391 Washington Street. It was originally set to open in time for the Pan American Exposition, but, due to financial problems, it didn't open until 1904. The hotel is a Buffalo landmark.

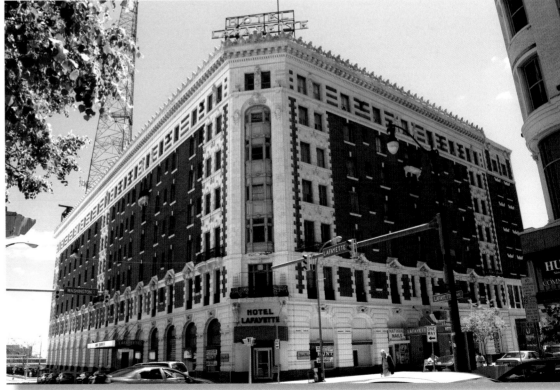

The Statler Towers:

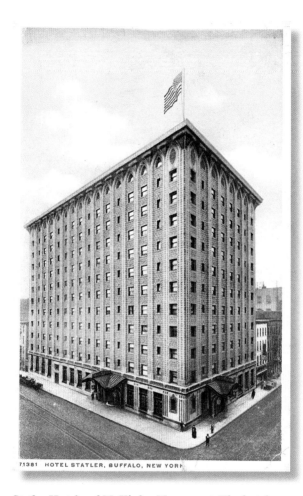

Statler Hotel and McKinley Monument. The hotel was built between 1921 and 1923 by architect George B. Post & Sons. Circa 1920s, divided back, $3-5.

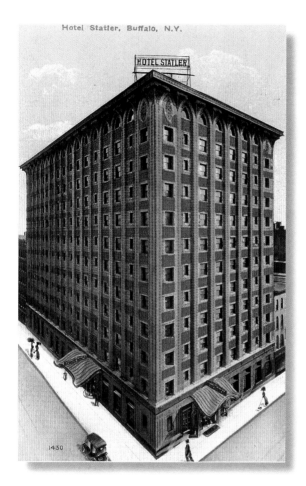

Hotel Statler. Ellsworth Statler revolutionized the restaurant business in Buffalo by aggressively advertising lunches for businessmen. The hotel was one of many that would form the Statler chain of hotels. His empire would last until 1954, when it was bought by Hilton. Circa 1910s, divided back, $3-5.

Hotel Statler. This postcard is of the first hotel built in 1896. Circa 1910s, divided back, $3-5.

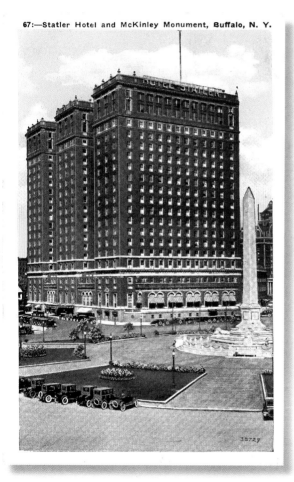

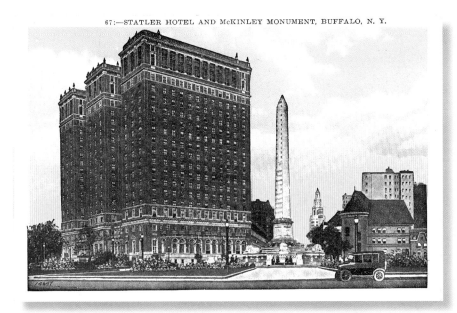

Statler Hotel. This postcard is of the second Statler Hotel built between 1921 and 1923. Canceled 1932, divided back, $3-5.

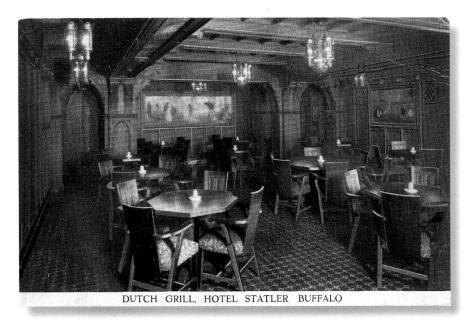

DUTCH GRILL, HOTEL STATLER BUFFALO

Dutch Grill, Hotel Statler. Circa 1910s, divided back, $3-5.

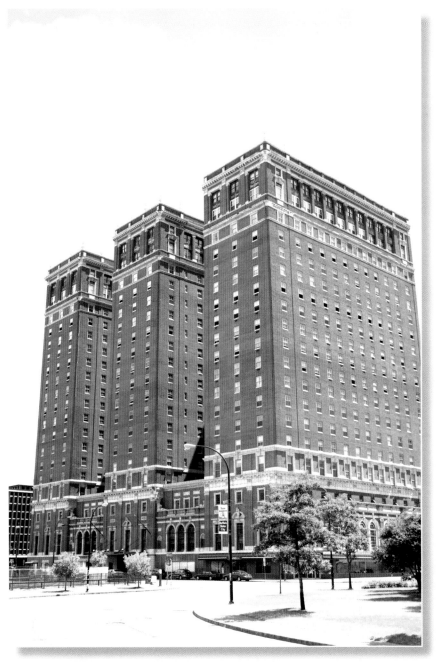

The hotel is located at 107 Delaware Avenue.

68

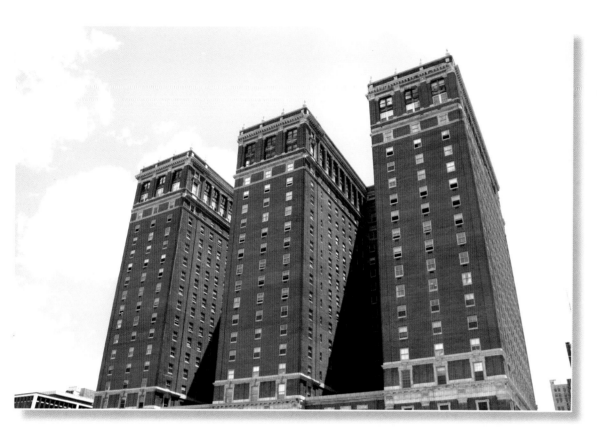

The three towers.

Side of the building.

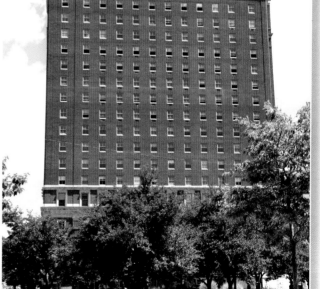

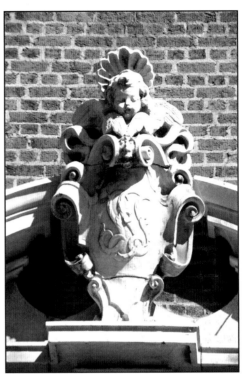

The Statler initials

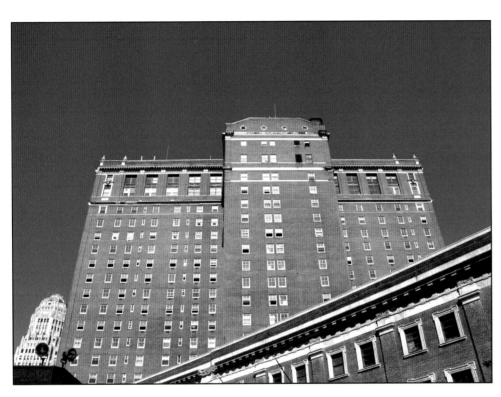

A view of the hotel from Mohawk Street.

The main entrance
to the Statler.

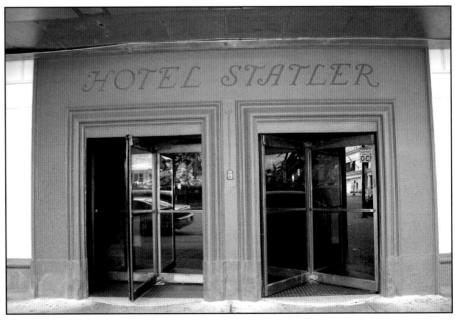

Century Grill/Society of Masons Lodge:

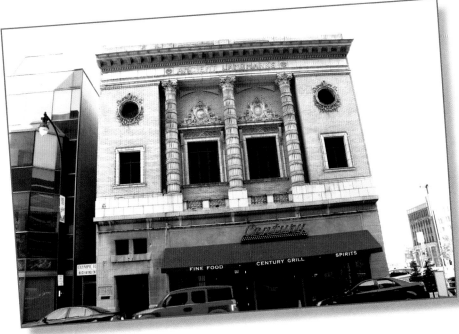

The Century Grill is located at 320 Pearl Street.

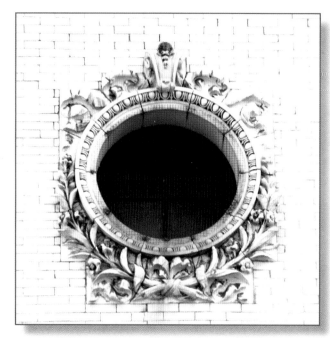

A detail of a window.

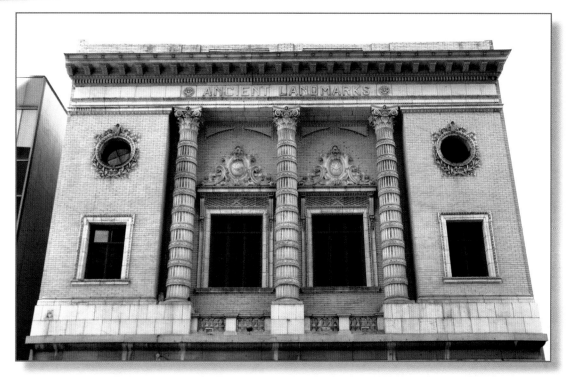

The building was constructed in 1904. The marquee is from the demolished Century Movie Theatre on Main Street.

Shea's Buffalo Theatre:

We went to the play on the evening of the day we spent at Buffalo (The Legitimate Drama at Buffalo!—what think you of that?), and found a good house, but a scanty and disreputable-looking audience. The performance was a curious medley; viz., one act of "King Lear," two of "A New Way to Pay Old Debts," with a farce and a melo-drama, and two comic songs between the acts of the tragedy and tragi-comedy. The same actor, like a second Garrick, played the principal part in all. We had not patience to sit it out, though he was really not so bad as we had expected—a ranter of the first water, of course, but with a good melo-dramatic figure and voice: I suspect he was a traveling 'star.' — *John Robert Godley, "Letters from America," 1844*

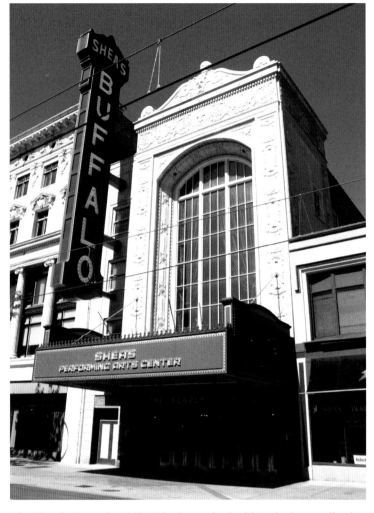

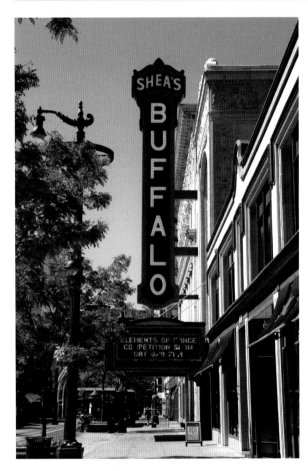

The building was erected in 1926. It is a nationally registered historic place and a Buffalo landmark. It was originally a movie palace. The owner and founder of Shea, Michael Shea, began in Buffalo by opening Vaudeville theatres. Here is a rather humorous reminiscence of a night spent out in Buffalo by one tourist at an unknown location.

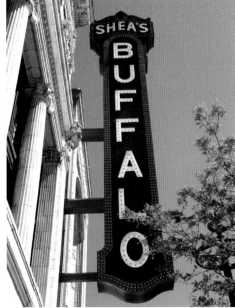

The Shea is located at 646 Main Street, in the historic theatre district. Buffalo has nine historic districts; Allentown, Linwood, Olmstead Parkways System, Hamlin Park, Delaware, Theater, Cobblestone, Ellicott, and the West Village.

A close up of the marquee. A little known fact about Buffalo is that it's home to the greatest number of theatres outside of New York City.

The Crowds:

Allentown Art Festival

The festival began in 1957 and was organized by local people in an area of Buffalo known as Allentown. The two-day festival in June sees artisans from across the country and Canada. Over 450 selected exhibitors displayed their wares in 2007, marking the 50th anniversary of the Allentown Art Festival.

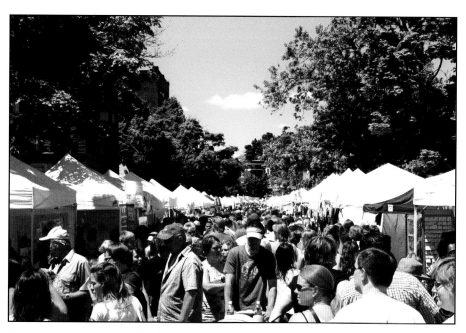

By noon the streets are filled.

The 2007 Allentown Art Festival. Allentown was the first designated historic neighborhood in Buffalo and is one of the largest historical neighborhoods in the United States. To learn more about Allentown, go to the web site www.allentown.org.

The Allentown Art Festival is held every June. This vibrant event is not to be missed.

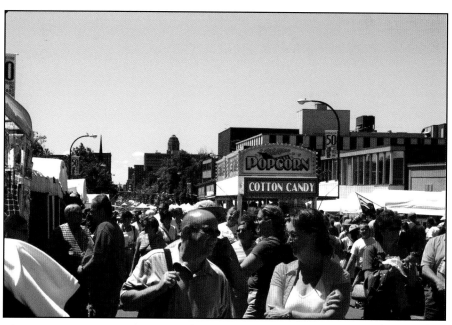

The Memories:

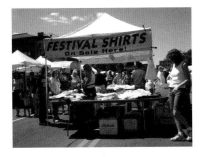

A plane made out of re-cycled Miller Genuine Light beer cans.

The Artisans:

Perusing the paintings.

Arrive early and visit as many of the art tents as possible. Each year this event sees more participants and more crowds.

There is a large selection of high quality handmade jewelry.

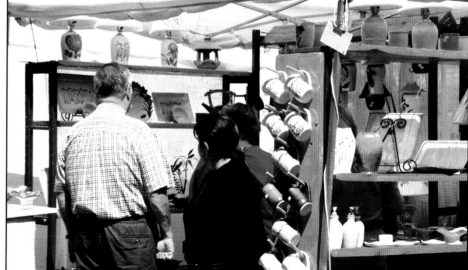

Pottery.

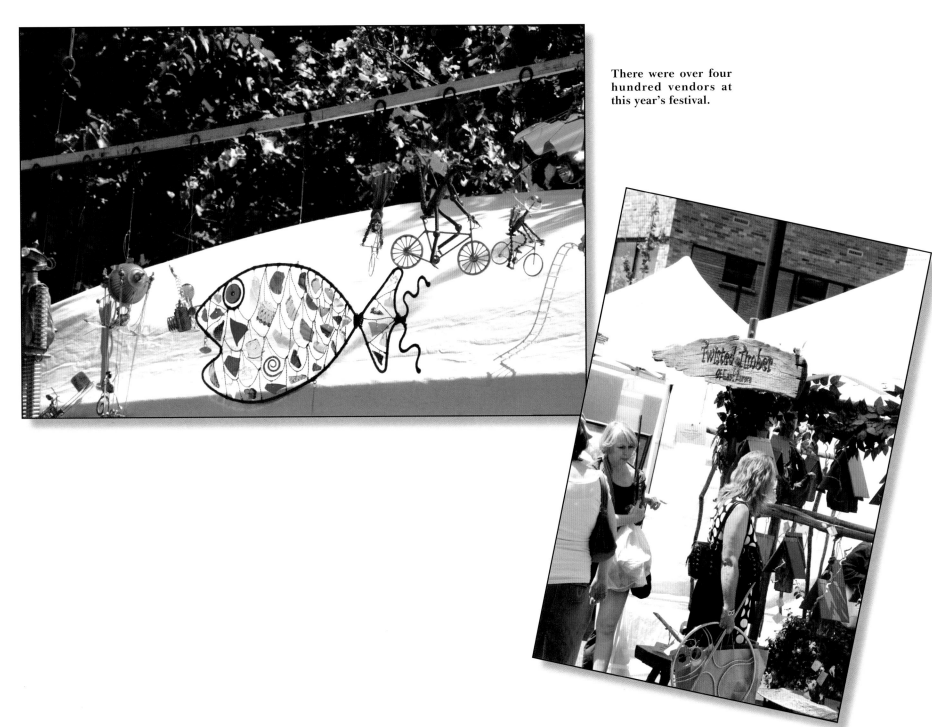

There were over four hundred vendors at this year's festival.

Many booths cater to the gardening crowd with a wide selection of unique lawn ornaments.

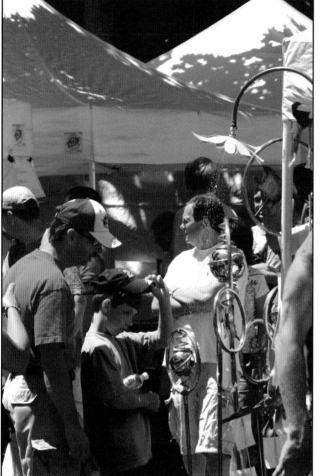

More than one person went home with a one of a kind sprinkler.

The Parrotville Beach booth along the Allen West Festival route. Even people who live in Buffalo can own their own palm tree.

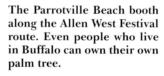

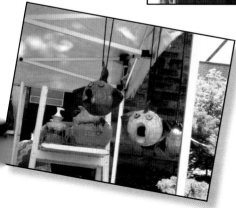

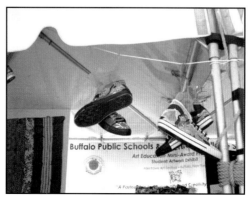

Wearable Art: The sneakers were part of the Buffalo Public School Students' pavilion showcasing award winning art projects.

The Vendors:

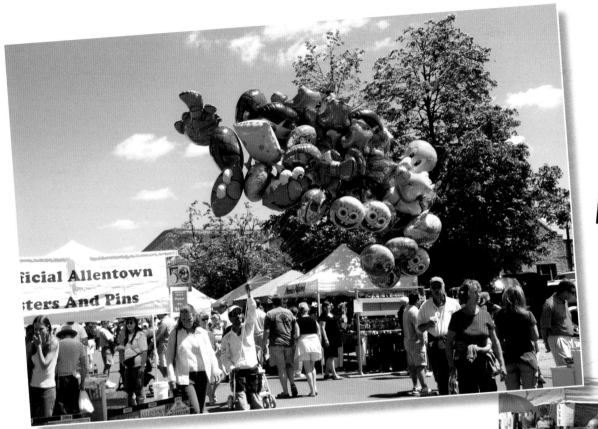

Balloons on Allen Street.

Setting up for the smallest visitors.

The Food:

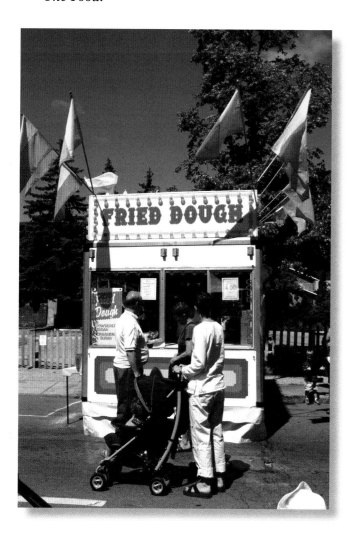

Fried Dough. Hmmm...where is the Buffalo specialty the "wreck," a roast beef sandwich on a salted roll.

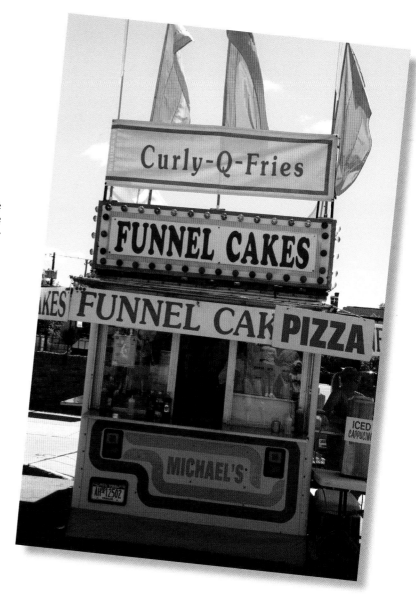

Do you like your funnel cakes with jam, powdered sugar or everything on it?

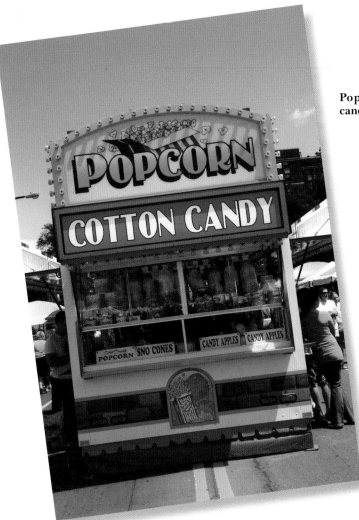

Popcorn and cotton candy are fair staples.

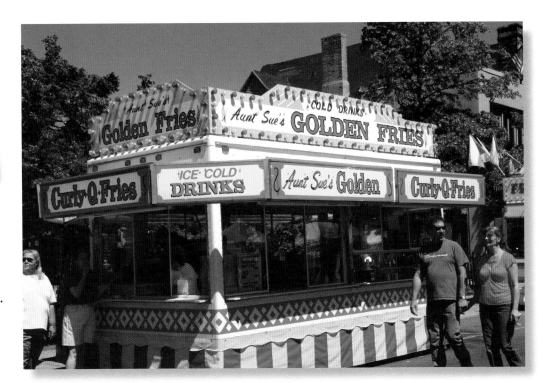

Golden Fries.

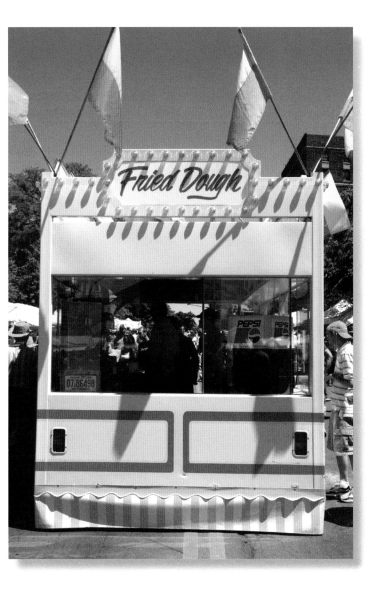

More fried dough stands!

Pizza.

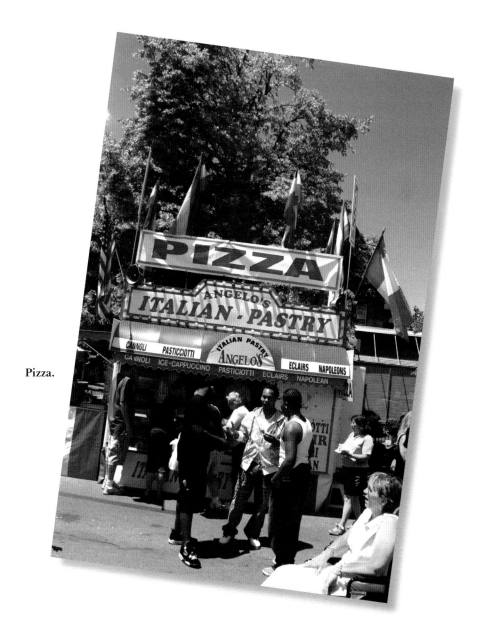

Drinks, cakes and cookies.

Bags of popcorn.

Tastes as good as it looks.

Snow cones are synonymous with summer.

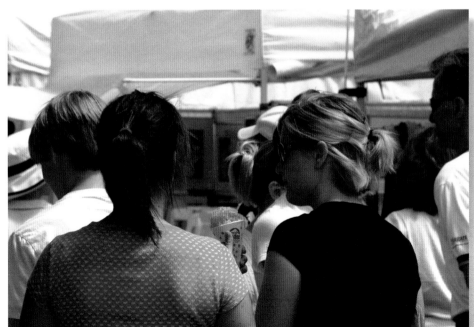

The Entertainment:

In all the activities of the festival, there are a handful of street performers.

Going to the Dogs:

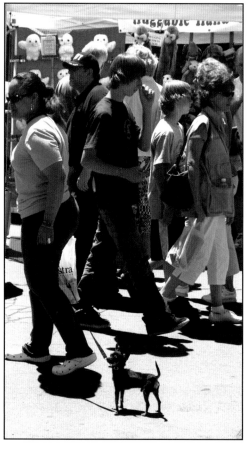

Take your best friend to the fair.

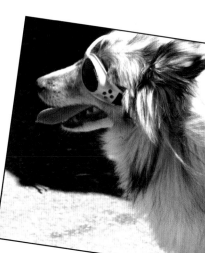

The dogs in Buffalo are so cool that they even wear shades.

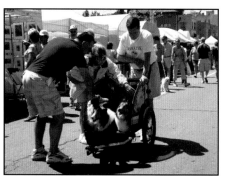

When the pavement is too hot for paws, some lucky dogs get to travel in style.

Taste of Buffalo:

Street Scenes:

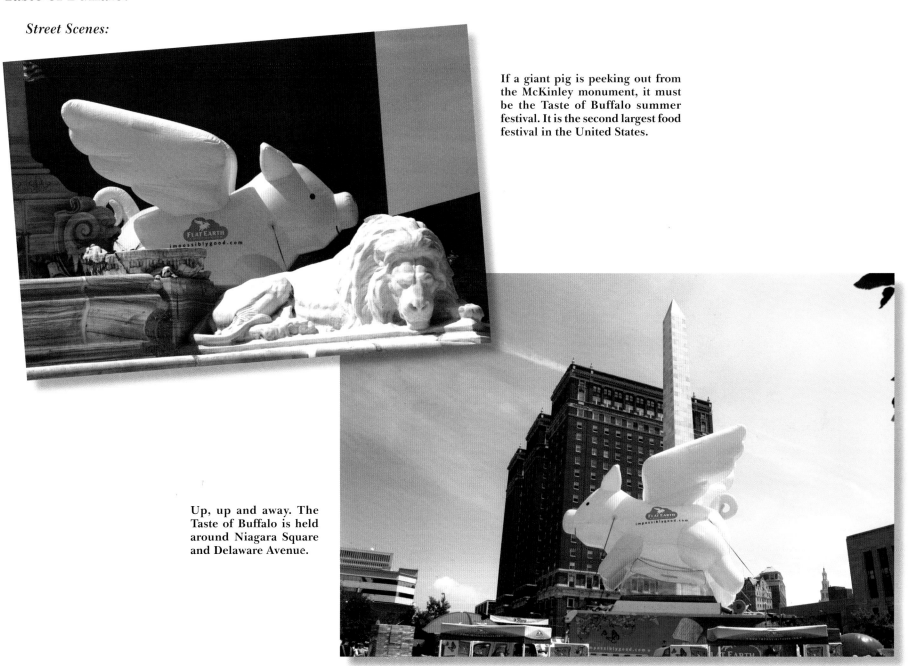

If a giant pig is peeking out from the McKinley monument, it must be the Taste of Buffalo summer festival. It is the second largest food festival in the United States.

Up, up and away. The Taste of Buffalo is held around Niagara Square and Delaware Avenue.

The line for soft serve ice cream. It must taste good if the line is this long!

More than fifty local restaurants participate in this two-day event. Wineries are represented as well.

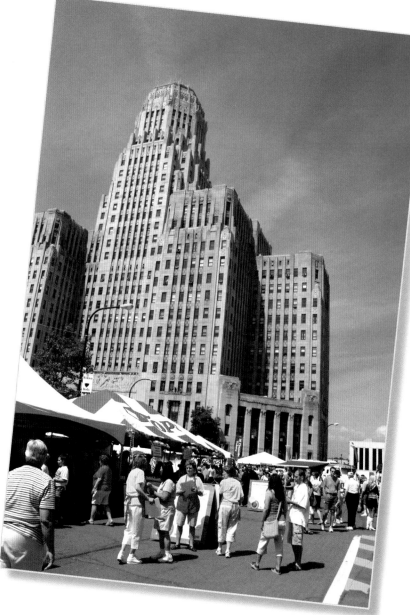

The Food:

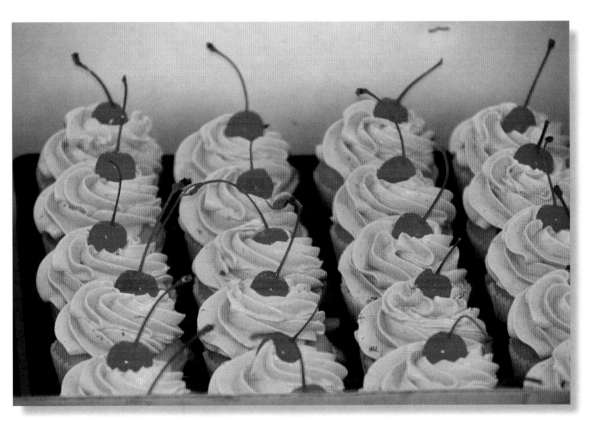

From the main courses to the desserts, the selection is just amazing. These summer delight cupcakes were available at Village Desserts.

This cone didn't remain looking this way for long!

A fine selections of wines.

Line up early at Nick Charlaps Ice Cream booth to get your banana nut sundae before the monkey does.

The kabob and curry stall before the lunch crowds. The festival features cuisine from around the globe. Pizza, curry, pasta, tortillas, shrimp gumbo and even German potato salad are just a few of the choices available.

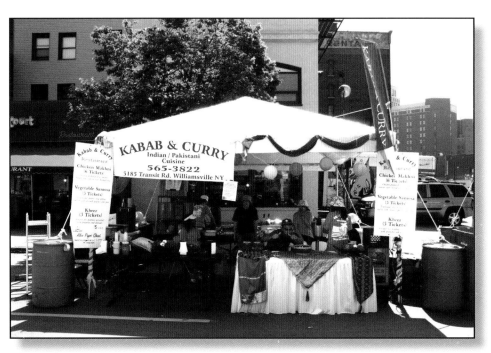

The People:

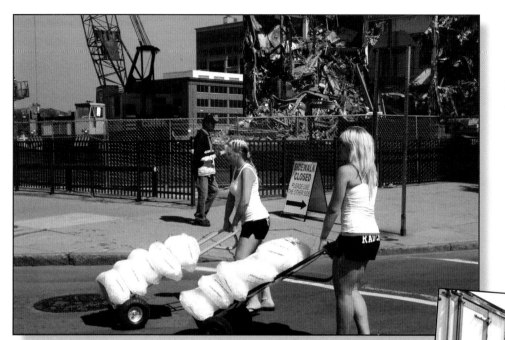

At the beginning of the day, the ice truck moves slowly up Delaware Avenue with these two girls behind, selling it off to the food stalls.

Handing out samples.

Tasting the samples. It's better when you share.

Louie's Texas Red Hots is a Buffalo institution.

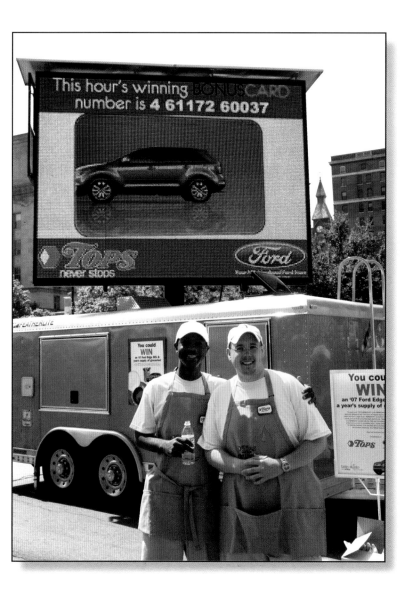

The guys from TOPS.

Real rock stars never put down their guitar. There are four stages at the festival, which ensure the entertainment never stops.

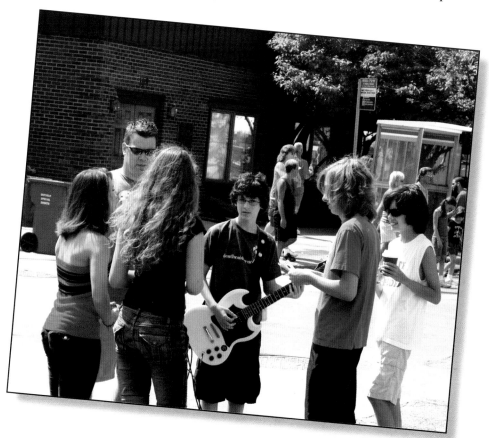

91

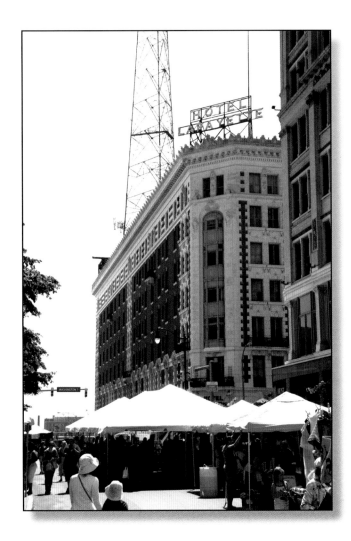

The book festival was held on the same day as the Food Festival in 2007. Here are a few of the stalls around Lafayette Square.

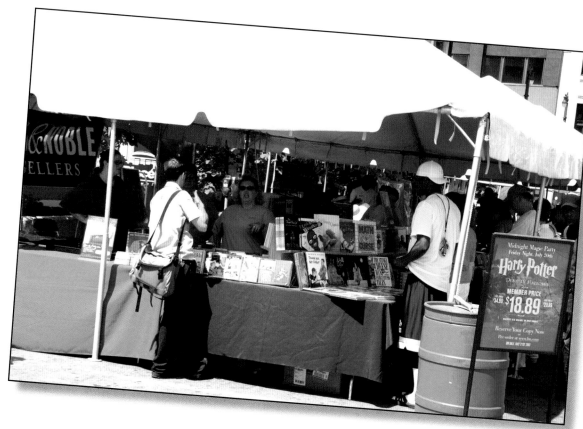

The fair features readings, book signings, seminars and activities for children such as the make and take crafts at the Think-Bright tent.

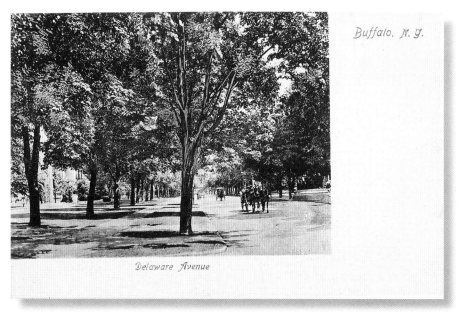

Buffalo, N. Y.

Delaware Avenue

This postcard shows the carriages along Delaware Avenue with its turn-of-the-century mansions. The mansions were built when vast fortunes were being made in railroad, lumber, banking and other industries. Circa 1900s, undivided back, $4-6.

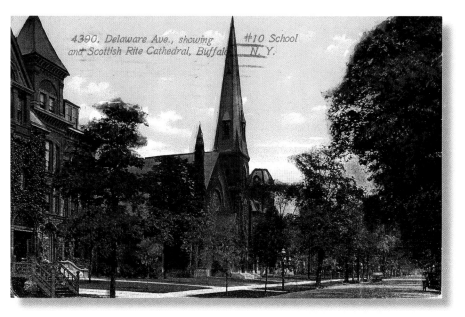

4390. Delaware Ave., showing #10 School and Scottish Rite Cathedral, Buffalo, N. Y.

Delaware Avenue showing #10 school and Scottish Rite Cathedral. Cancelled 1913, undivided back, $3-5.

Delaware Avenue

After all the excitement of downtown, a drive along Delaware Avenue will lead you by some of the most magnificent mansions built in Buffalo.

"In the neighbourhood(sic) of Buffalo are some very well built detached residences, some of them very fine mansions; and amongst the number is that of Milward Filmore, an ex-President of the United States. Having an introduction to this personage, it was not to be supposed that I should leave Buffalo without affording myself the gratification of shaking by the hand and talking with a live President! The fates however had ordered it otherwise. On proceeding with my friend to Mr. Filmore's, we had the disappointment to find that Mr. and Mrs. Filmore were not at home—they had gone to New York for a short time; but with great politeness, (on my friend explaining that I was an Englishman who much wished to pay my respects to the late President), we were shown over the house. The paintings and library were of the first order, and the general good taste displayed in the arrangement of everything elicited my admiration." — *TDL, "A Peep at the Western World: Being An Account of a Visit to Nova Scotia, New Brunswick, Canada, and the United States," 1863*

Theodore Roosevelt Site:

"The custom was early established of setting the houses at least ten feet back from the street line, and of planting several rows of trees before them; and the especial pride of Buffalo is her fashionable residence district, in which each house is surrounded by ample grounds guiltless of the abomination of fences and embellished with shrubs and trees, giving a great city the appearance of a handsome suburb. All the streets in this region are paved with asphalt, of which there are over one hundred and twenty-two miles, as against one hundred and thirty-one miles of stone and one hundred and thirty-two miles of unpaved streets in the outskirts." — *Frederick J. Shepard, "The City of Buffalo," The New England magazine, Vol. 14, Issue 2, April 1893*

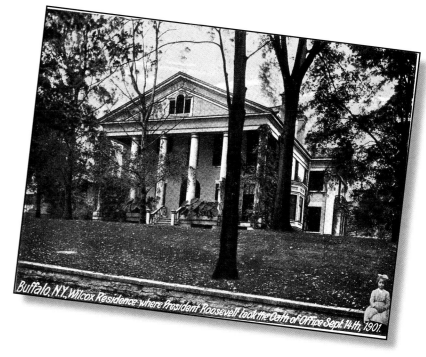

Wilcox Residence where President Roosevelt took the oath of office on September 11, 1901. This present-day Theodore Roosevelt Inaugural National Historic site was previously the Ansley Wilcox House. The site opened to the public in 1971. Circa 1910s, divided back, $4-6.

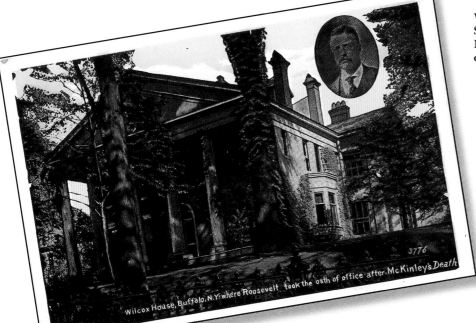

Wilcox Residence, where President Roosevelt took the oath of office after McKinley's death. On the guided tour of the residence, you will be shown the exact spot in the library where this took place. Circa 1910s, divided back, $4-6.

Right & below:
The home is located at 641 Delaware Avenue. It is a Buffalo landmark and on the National Register of Historic Places.

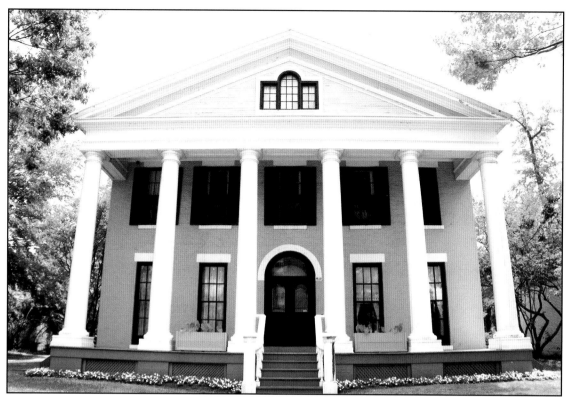

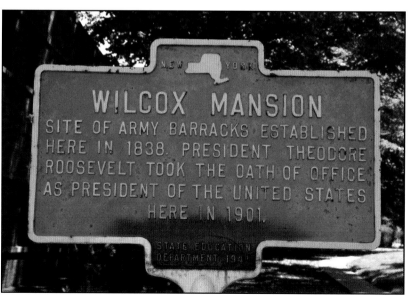

The Milburn Residence:

"Delaware Avenue is the leading street of Buffalo for private residence, and here much of the aristocracy do congregate. It is about three miles long, and double rows of shade trees either side. Fast driving on this avenue is licensed by city authority, and racing down its gentle incline is much in vogue. In winter, when sleighing is good, this is carried to greater access, and the snowy road is black with flying vehicles. Main street, the principal business thoroughfare of the city, at least for retail trade, is wide, well, paved and straight, and is built up with substantial business blocks." — *Willard W. Glazier, "Pecularities of American Cities," 1886*

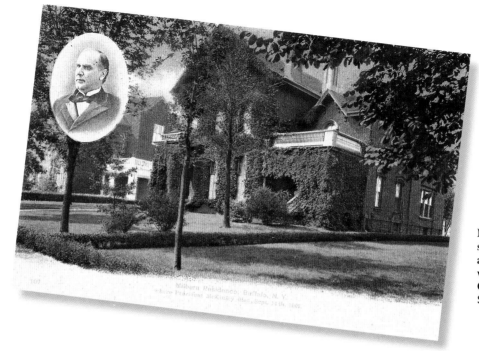

Milburn Residence. The current site of the Milburn residence is a car parking lot. The building was demolished in the mid-1950s. Cancelled 1910s, divided back, $3-5.

Delaware Park

"The most interesting general fact of my life seems to me to be that it was not as a gardener, a florist, a botanist, or one in any way specially susceptible to their beauty, that I was drawn to my work. The root of all my work had been an early respect for and enjoyment of scenery, and extraordinary opportunities for cultivating susceptibility to its power. I mean not so much grand or sensational scenery as scenery of a more domestic order — scenery which is to be looked upon contemplatively, and is productive of musing moods." — *Frederick Law Olmstead, The Century, Vol. 46, Issue 6, October 1893*

Present:

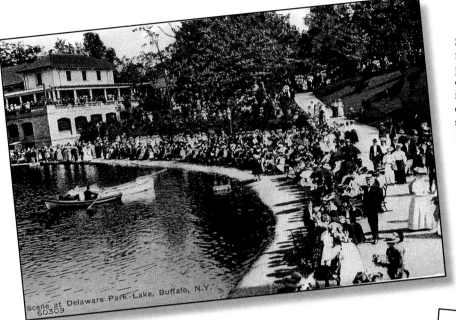

Scene at Delaware Park-Lake, Buffalo, N.Y.
60309

Scene at Delaware Park Lake. Here's a math equation for you: What do six major parks, eight connecting parkways, nine circles, and seven smaller spaces equal? They equal the first park and parkway system in the nation. The father of American landscape design, Frederick Law Olmsted, is responsible for seventy-five percent of Buffalo's parkland. Circa 1910s, divided back, $4-6.

Scene in Delaware Park. Delaware Park was first simply known as 'The Park.' It was constructed in 1871. There are six parks in the Frederick Law Olmsted park system; Cazenovia, Delaware, Front, Martin Luther King Jr., Riverside and South Park. Frederick Law Olmstead is considered the father of American landscape architecture. He is even credited with first using this term. To learn more about him, see the official web site at www.olmsted.org. Cancelled 1908, divided back, $3-5.

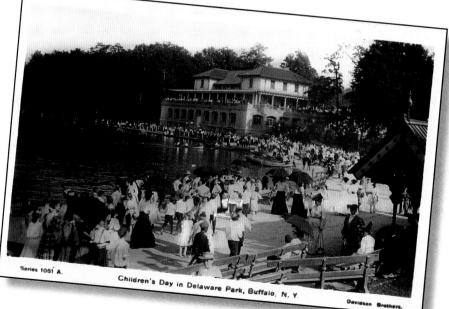

Series 1051 A.

Children's Day in Delaware Park, Buffalo, N. Y.

Davidson Brothers.

Delaware Park. The park has the distinction of being one of Olmstead's first three Buffalo parks. The parkways are Lincoln, Bidwell, Chapin, Richmond, Porter, Red Jacket and McKinley. The circles are Soldiers, Gates, Colonial, Ferry, Symphony, McClellan, and McKinley. Circa 1900s, divided back, $3-5.

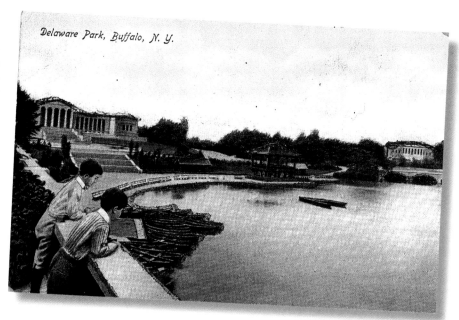

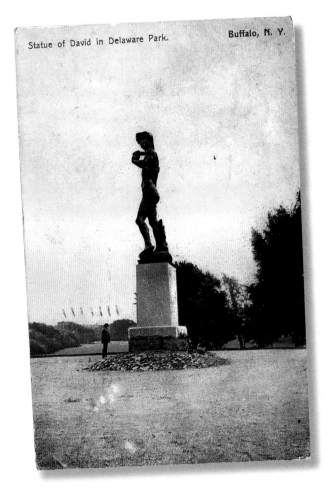

Statue of David in Delaware Park. The statue was purchased at the Paris Exposition in 1900 and gifted to the city of Buffalo Historical Society by Andrew Langdon. Cancelled 1909, divided back, $4-6.

Park scene, Delaware Park. Circa 1900s, undivided back, $4-6.

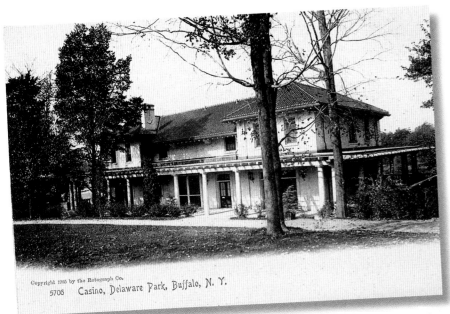

5706 Casino, Delaware Park, Buffalo, N. Y.

Casino, Delaware Park. This popular meeting place with Buffalonians at the turn-of-the-century. The building after being destroyed by fire was redesigned by E.B Green into a Mediterranean villa. Boating strolling or canoeing, this was the place to come for residents of Buffalo. Circa 1900s, undivided back, $4-6.

Buffalo Historical Society Building, Delaware Park. Today, The Buffalo and Erie County Historical Society is here. Circa 1904, undivided back, $4-6.

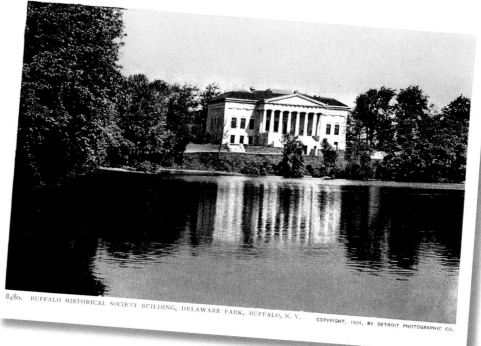

8480. BUFFALO HISTORICAL SOCIETY BUILDING, DELAWARE PARK, BUFFALO, N. Y. COPYRIGHT, 1904, BY DETROIT PHOTOGRAPHIC CO.

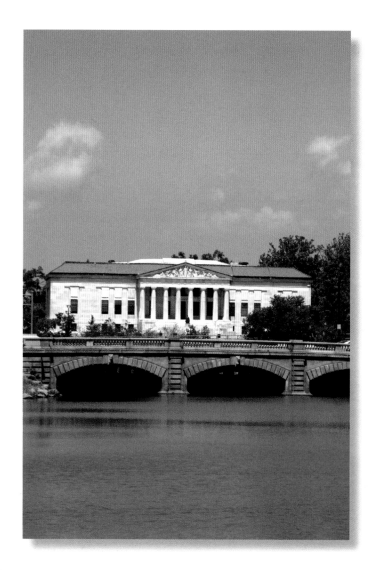

The Historical Society Building is located at 25 Nottingham Court. The building is a Buffalo landmark, a national Historic landmark and it is on the National Register of Historic Places. Cancelled 1911, divided back, $3-5.

Looking across
Hoyt Lake.

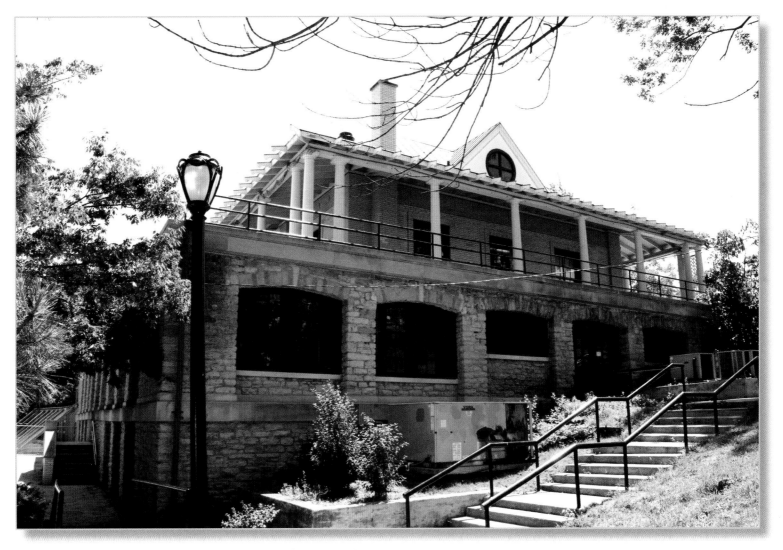

The Delaware Park Casino. It was constructed in 1874 as a boathouse.

Biking around Delaware Park is a popular summertime activity.

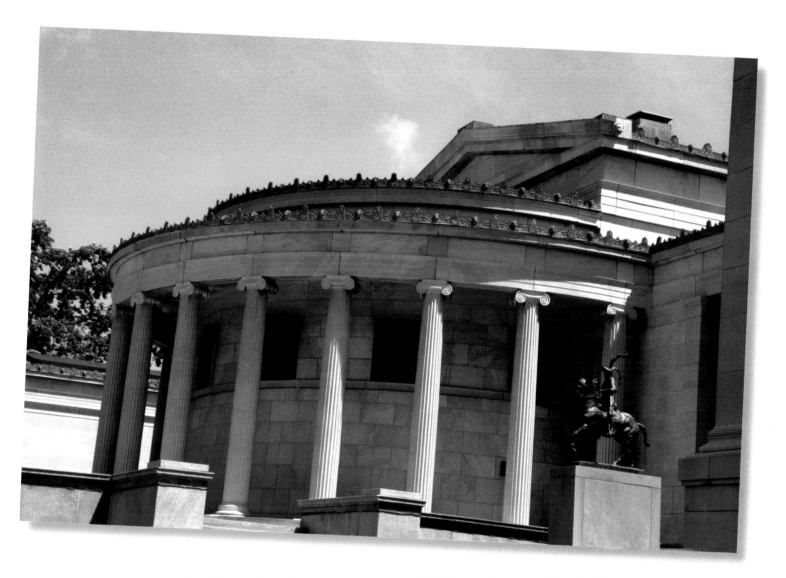

The Albright-Knox Art Gallery is located at 1285 Elmwood Avenue. It is a Buffalo landmark and on the National Register of Historic Places.

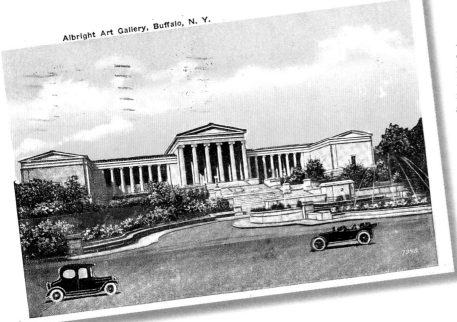

Albright Art Gallery, Buffalo, N. Y.

Albright Art Gallery. The building was completed in 1905, though originally intended as the fine arts pavilion for the Pan American exhibition in 1901. The museum was a gift from entrepreneur and philanthropist John J. Albright. Circa 1910s, divided back, $3-5.

Albright Art Gallery. The building was renamed the Albright-Knox Art Gallery in 1962 after contributions by Seymour H. Knox and others made this expansion possible. Cancelled 1918, divided back, $3-5.

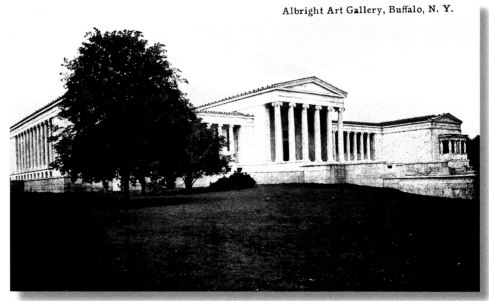

Album Five:

Niagara

"Stranger—if you are now ready, we will proceed to the Office of the Buffalo and Niagara Falls Railroad Depot, to the Terrace, immediately under the Western Hotel, and procure tickets. It is now nearly 9 o'clock and almost time to be aboard the cars. They go at 9 a.m. and 5 p.m. — Look sharp, the bell ring, and here goes. The road has been very recently re-laid with the T-rail and the speed is now equal to anything in the United States. Very pleasant cars, careful engineers, and the most affable conductor to be found between this and the unknown regions about the North Pole." — *Burke's Descriptive Guide, by an old Resident, 1851*

The View

"Let us now proceed through the grove to Prospect Point, the best view of the Falls from the American side. As we advance towards its presence, the thunder of Niagara rolls awfully on our ears; and now a turn in the walk brings us in front of Prospect Point Cottage, where the senses are instantly captivated by the sight." — *Burke's Descriptive Guide, by an old Resident, 1851*

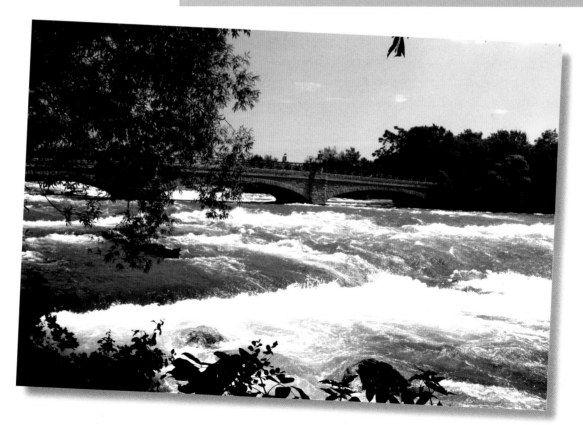

The rapids by the pedestrian bridge.

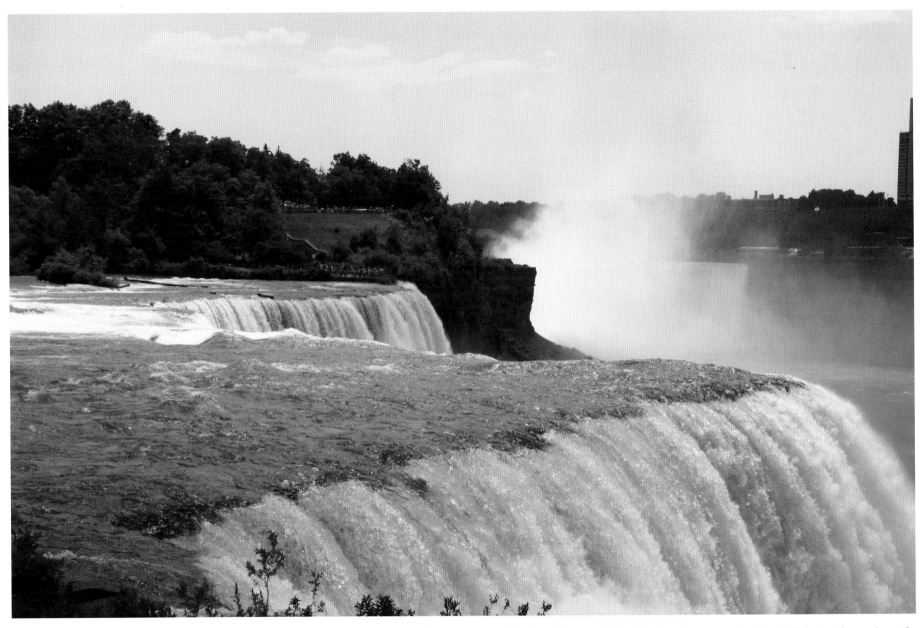

The American Falls by Prospect Point. *"Buffalo, January 14: This town situated twenty-seven miles from Niagara Falls. The Americans say that the Buffalo people can hear the noise of the waterfall quite distinctly. I am prepared to believe it. However, an hour's journey by rail and then a quarter of an hour's sleigh ride will take you from Buffalo within sight of this, perhaps the grandest piece of scenery in the world. Words cannot describe it. You spend a couple of hours visiting every point of view. You are nailed, as it were, to the ground, feeling like a pigmy, awestruck in the presence of nature at her grandest. The snow was falling thickly, and though it made the view less clear, it added to the grandeur of the scene." — A Frenchman in America, Recollections of men and things." Max O'Rell (pseudo.), 1891.*

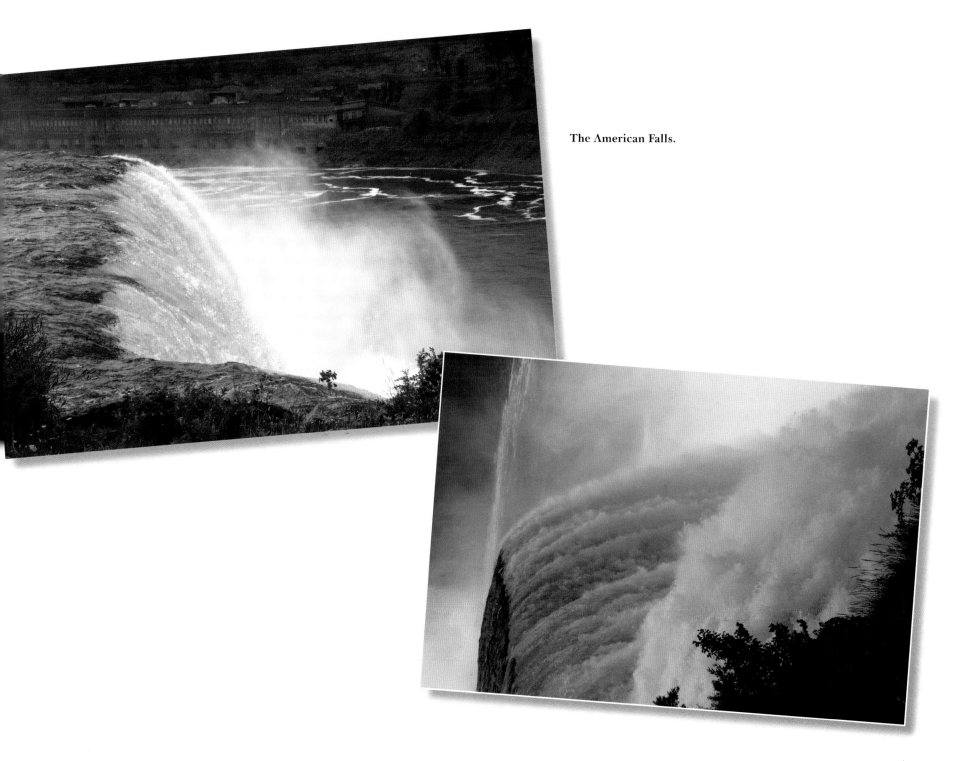

The American Falls.

The People

"The electric car line between Buffalo and Niagara Falls equipped with elegant and commodious cars running every fifteen minutes, makes Niagara Falls more accessible than ever. It is a delightful ride, particularly during the summer season and is patronized very extensively by the residents of Buffalo. In fact, this line has a tendency to make the Falls a suburb of Buffalo." — *A New Guide To Niagara Falls & Vicinity, Rand, McNally & Co., publishers, 1895*

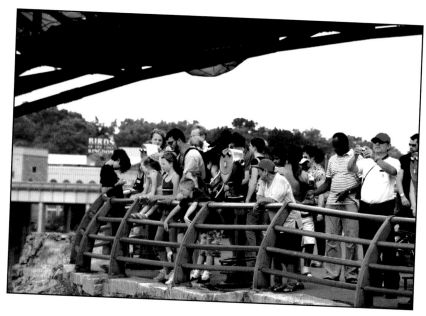

The crowds at Prospect Point.

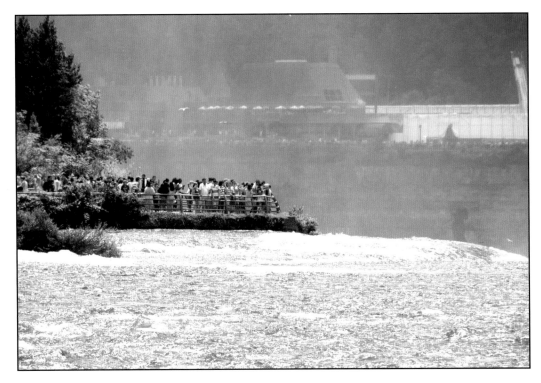

The crowds at Terrapin point.

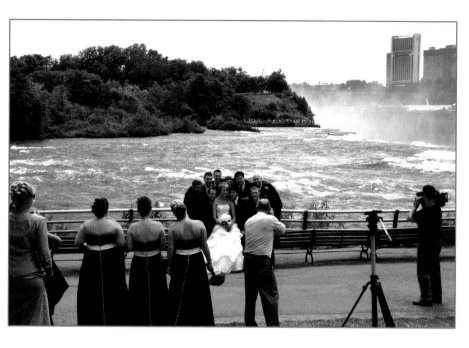

The Falls is always a popular picture-taking spot for wedding parties.

Tourists lined up for the "Maid of the Mist." The Maid of the Mist Steamboat company was created in 1884.

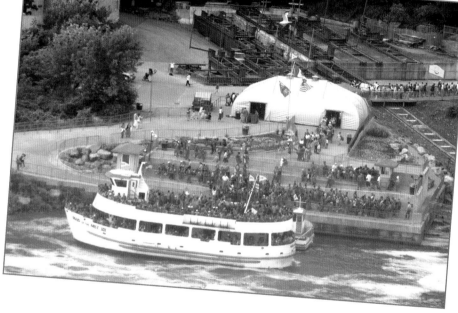

Running in Great Lakes' garden.

Bibliography

Books

Banham, Reyner, Beveridge, Charles, and Hitch, Henry-Russell. *Buffalo Architecture: A Guide*. Cambridge, Massachussetts: MIT Press, 1981.

Dunn, Walter S., Jr., ed. *History of Erie County, 1870-1970*. Buffalo, New York: Buffalo and Erie County Historical Society, 1972.

Gray, David. *Art Handbook: Official Handbook of Architecture and Sculpture and Art Catalogue to the Pan-American Exposition*. Buffalo, New York: Matthews-Northrup, 1901.

Leary, Thomas E. and Sholes, Elizabeth C. *Buffalo's Waterfront*. Arcadia Publishing, 2006.

Goldman, Mark. *High Hopes: The Rise and Decline of Buffalo*. Albany, New York: State University of New York Press, 1983.

Van Ness, Cynthia. *Victorian Buffalo: Images from the Buffalo & Erie County Public Library*. Western New York: Wares Inc., 1999.

Newspapers

Buffalo Daily Courier
The Daily Buffalonian
The New England Magazine
Harpers New Monthly Magazine

Foot Notes

1. *A New Guide to Niagara Falls and Vicinity*. Rand McNally & Company Publishers, 1895. Pg. 11.

"But, tough Buffalo was destroyed by fire, it shortly evinced all the power of the fabled phoenix, and rose from its ashes to a grander future than its early settlers ever dreamed of prophesying for it. The young city, however, suffered in its first days from a multiplicity of names, struggling under no less than three. The Indians named it Te-osah-wa, or 'Place of Basswood;' the Holland Land Company dragged the Dutch name of New Amsterdam across the ocean and endeavored to drop it at the foot of Lake Erie; and finally, it took its present name of Buffalo from the frequent visits of the American Bison to a salt spring which welled up about three miles out of the village on Buffalo creek. Think Buffalonians have reason to be grateful that the last name proved more tenacious than the other two. Think of the 'Queen City' of the most Eastern West being overshadowed by the tile-roof name of New Amsterdam!" — *Willard W. Glazie, traveler, "Pecularities of American Cities," 1886*

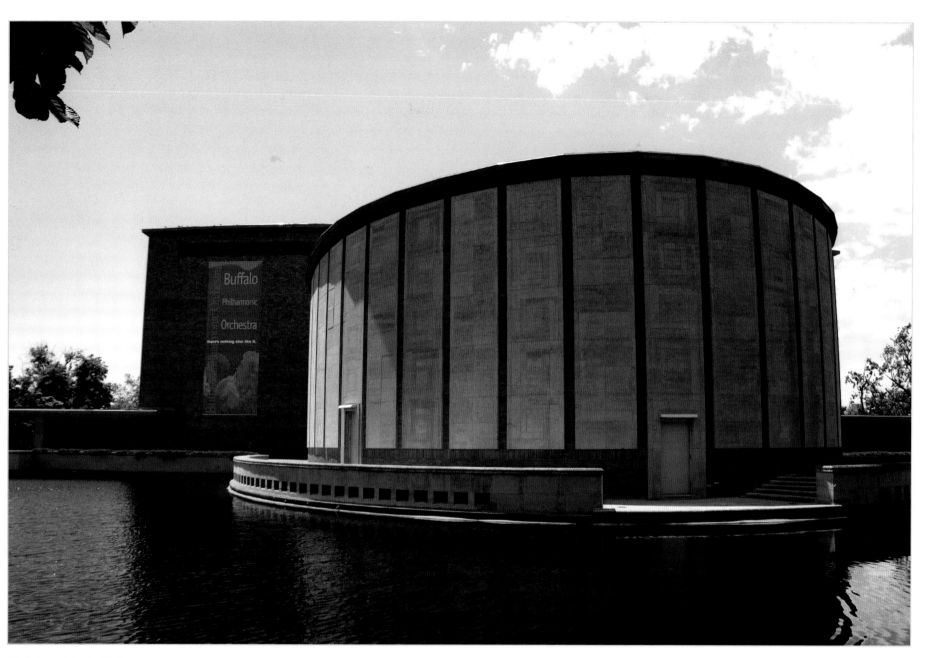

Kleinhans Music Hall

Index